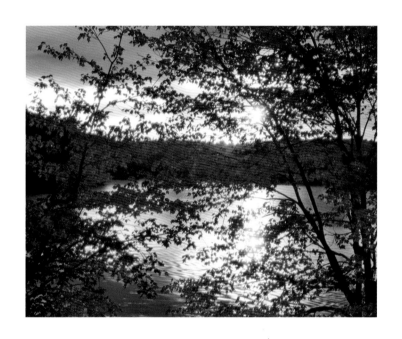

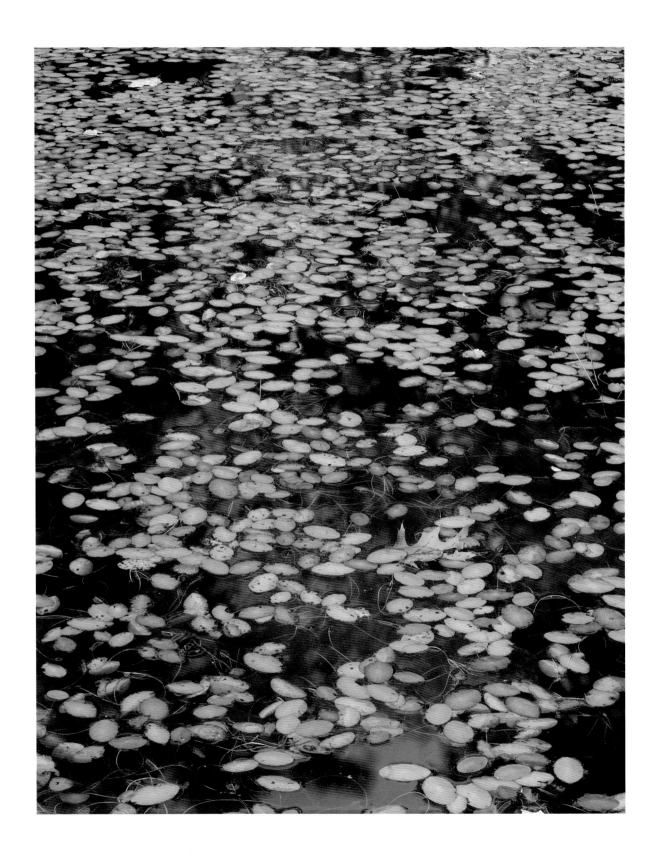

THE ILLUMINATED™

WALDEN

IN THE FOOTSTEPS OF THOREAU

Excerpts from the book *Walden, or Life in the Woods,* by Henry David Thoreau
Edited by Ronald A. Bosco, President, The Thoreau Society
Foreword by Don Henley

Photographed by John Wawrzonek
at Walden Pond and Walden Woods
1991 ~ 2002

BARNES
&NOBLE
BOOKS
NEW YORK

The authors owe their inspiration to the natural environment and to the life and writings of Henry David Thoreau.
It is hard to conceive of another man whose life and writings have had such a profound effect on the American vision.

A BARNES & NOBLE BOOK

The Illuminated™ *Walden* ©2002 by John J. Wawrzonek
Thoreau text ©2001 by Dr. Ronald A. Bosco
All photographs ©2001 by John Wawrzonek

Base map courtesy of the Thoreau Country Conservation Alliance; drawn by Stuart Weinreb; final design by Susan Ziegler

ISBN 0-7607-4491-2

Project Editor: Betsy Beier
Art Director: Jeff Batzli
Designer: John Wawrzonek
Photography Editor: Chris Bain
Production Manager: Michael Vagnetti

Printed in Singapore by CS Graphics Pte Ltd.

1 3 5 7 9 10 8 6 4 2

Note: Excerpts from Thoreau's *Walden, or Life in the Woods* have been drawn from the first edition of 1854 in the Walter Harding Collection of the Thoreau
Society Collections at the Henley Library, The Thoreau Institute at Walden Woods, Lincoln, Massachusetts.

CONTENTS

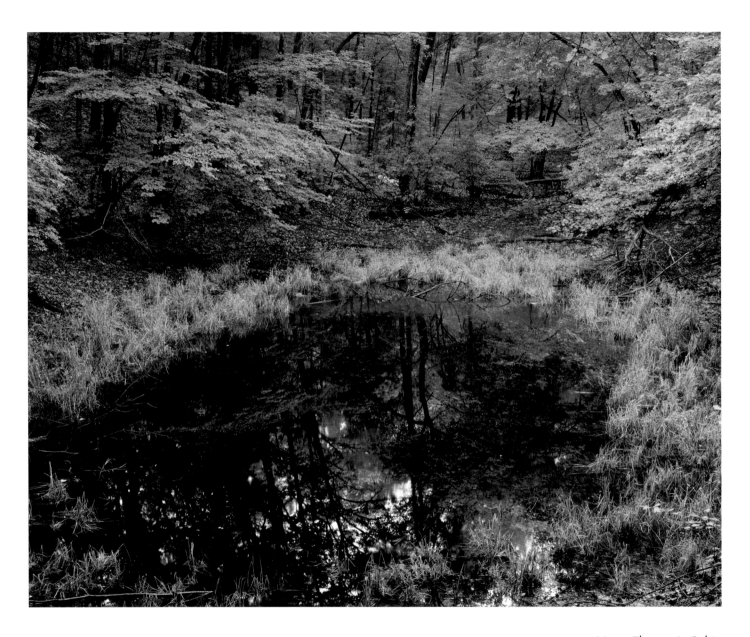

Near Thoreau's Cabin

FOREWORD BY
DON HENLEY

I open my foreword to *The Illuminated Walden* this way, in deference to Thoreau, who remarks at the beginning of *Walden*, "I . . . require of every writer . . . a simple and sincere account of his own life, and not merely what he has heard of other men's lives."

Since the time I was first introduced to Henry David Thoreau's writings by one of my high school teachers, they have continued to exert a profound effect on me. Like the literature of other great American authors—Ralph Waldo Emerson, Robert Frost, and, more recently, E.O. Wilson—Thoreau's books, essays, and journal resonated with me and confirmed certain truths about human nature and one's ideal relationship to the natural world.

The Illuminated Walden is the result of a collaboration between unlikely partners: John J. Wawrzonek, an internationally recognized photographic artist, and Ronald A. Bosco, an eminent literary scholar. They have brought their own experiences, talents, and vision to this effort. Yet, this extraordinary book has emerged as a unified statement about all of us—about our shared respect for Thoreau's spirit of independence, our admiration for his appreciation of the natural splendor of Walden Pond and Walden Woods, and our mutual responsibility to preserve both of these extraordinary places for the inspiration and enjoyment of future generations.

In 1990, I founded the Walden Woods Project, a nonprofit organization with the mission of permanently protecting the unique natural, cultural, and historic environment of Thoreau's Walden. To honor Thoreau's legacy of living harmoniously with the environment, we needed to start by protecting the very land that inspired him—Walden Woods—the place many refer to as "the cradle of the American environmental movement." I believed then, as I do now, that if we do not preserve the place where the idea of land conservation first took root, then we will never succeed in protecting other environmentally sensitive and historically significant places throughout the world. For all practical purposes, Walden Woods is the epicenter of the environmental movement. Our work had to begin there, where Thoreau's work left off.

In the past twelve years, the Walden Woods Project has protected almost 140 acres (56ha) in and around historic Walden Woods. Nearly 70 percent of the 2,680 acres (1,072ha) comprising Walden Woods is now protected by various public and private entities. But many challenges remain for the Walden Woods Project, not the least of which is reclaiming, restoring, and preserving the site of a former landfill near Walden Pond.

Thoreau occupies a special place in American history as one of our country's first and most ardent conservationists. His compelling philosophy on man's relationship to the natural world influenced generations of writers and environmentalists who followed, including John Muir, Aldo Leopold, and Rachel Carson. The writings of Thoreau and the place that inspired him are inextricably connected, just as the artistic photography of Walden is inextricably connected to Thoreau's thoughts in this book. *The Illuminated Walden* transports us, through visual images and through the written word, to Thoreau's woods on the shores of Walden Pond. Whether you have visited Walden Woods or not, this book will take you there. After experiencing it, you will better understand why so much is being done to protect this national treasure. To Thoreau's eye, the beauty and inspiring prospect of Walden Pond and Walden Woods reinforce each other. As Thoreau said in his journal, here, "I am whole and entire."

Don Henley
March 1, 2002

EDITOR'S INTRODUCTION

He is richest who has most use for nature as raw material of tropes and symbols with which to describe his life. . . . If I am overflowing with life, am rich in experience for which I lack expression, then nature will be my language full of poetry. . . . I pray for such inward experience as will make nature significant.

Toward the end of March 1845, Henry David Thoreau borrowed an axe and walked the mile from Concord Center to the woods on the Concord side of Walden Pond, where he intended to clear a small parcel and build a house. The woods belonged to Ralph Waldo Emerson, who had offered Thoreau use of the site to perform what Emerson may have thought was just another of his friend's ritualistic escapes into nature—"ritualistic," because Thoreau already had a reputation for never traveling far from home to escape from or challenge the commonplace realities of mid-nineteenth-century life in the wonderfully diverse world of nature. Over the next several months, Thoreau finished off his house, spending, as he pointed out with a certain degree of Yankee pride, only twenty-eight dollars and twelve-and-a-half cents on the entire project. But long before he had comfortably settled into his house and the first winds of the winter of 1845–1846 had begun to blow, Thoreau found himself having to answer the queries and stares of friends and neighbors about this, his most recent, but also most radical, escape into nature. As he states it in *Walden, or Life in the Woods*, his answer was a simple one—one all the more eloquent and inspiring for its simplicity:

I went to the woods because I wished to live deliberately, to front only the essential facts of life, and see if I could not learn what it had to teach, and not, when I came to die, discover that I had not lived. I did not wish to live what was not life . . . nor did I wish to practice resignation. . . . I wanted to live deep and suck out all the marrow of life, to live so sturdily and Spartan-like as to put to rout all that was not life, . . . to drive life into a corner, and reduce it to its lowest terms, and, if it proved to be mean, why then to get the whole and genuine meanness out of it, . . . or if it were sublime, to know it by experience.

Thoreau lived at Walden Pond for two years, two months, and two days. When he left the pond on September 6, 1847, he had completed a two-year cycle of life in which he came to terms with both the meanness and the sublimity of life. "A lake," he wrote in *Walden*, "is the landscape's most beautiful and expressive feature. It is earth's eye; looking into which the beholder measures the depth of his own nature." Looking on Walden, peering into its depths, Thoreau plumbed the depth of human nature. On the one hand, his rustic life at Walden Pond was literally only a short step back and away from the lives of his fellow Concordians, people, he felt, whose physical and spiritual independence had been mortgaged to their lands, or to their professions, or to the expectations that convention, family, teachers, government, or church had placed upon them. But the freedom of Thoreau's life at Walden put their lives into stark relief. Their lives, he decided, were acts of "stereotyped . . . despair" in which they were robbed of their humanity as well as their freedom to choose a way of life for themselves. On the other hand, Thoreau's own life at Walden Pond was sublime. It was sublime because it was an independent life that offered him the chance to identify and indulge his competing instincts toward both a mystic, spiritual life and a primitive, savage one. At Walden, Thoreau tested the relative merits of society and solitude and found that both were necessary to complete a man. He immersed himself in nature for nature's own sake, as when he paused to appreciate her beauty, and to master the lessons nature taught him through the constancy of her rhythms across the seasons, the habits of her animals with whom he shared the woods, and her fables of his life that elevated his experience to poetry.

On the shore of Walden Pond, as elsewhere in Concord's pastoral setting, Thoreau was always at ease. Nature piqued his fertile imagination, and in nature he transformed his contemporaries' preoccupation with material reality into meditations on their spiritual condition as well as on his own. Years before, as he confided in his journal, he came to believe that nature offered him an inexhaustible array of luxuries, among which he included standing up to his chin in a hidden swamp for a whole summer's day, scenting the sweet fern, and being lulled by the minstrelsy of gnats and mosquitoes and cheered by genial conversation with a leopard frog. In the summer swamp, as in any place and at any time of the year as long as he was out in nature, Thoreau felt himself expand to an existence as wide as the universe, and he confirmed his chief article of faith: "Nature is full of genius, full of divinity."

Thoreau's posture throughout *Walden* represents an extended application of Emerson's theory of the ideal relation between the individual and nature. In his essay "Nature" (1836), Emerson declared the divinity of human life and pronounced nature the site to which individuals had to repair in order to rediscover the "original and eternal beauty" of their universe and achieve the redemption of their souls. Nature announced a new gospel, which Emerson later defined as "the infinitude of the private man," and it provided the generation into which Thoreau was born with one commandment: "Build . . . your own world."

The house-building Thoreau began on that cold March day in 1845 was an act of creation analogous to his building of a new world, and the world he would eventually create at Walden Pond and capture in the poetic prose of *Walden* was a very special test of nature's genius and divinity as well as of his own. He began by cutting down the "arrowy" white pines near the site overlooking the Pond where he intended to build his house, hewing them into studs, rafters, and floor timbers as he went along. During April, May, and June he worked on the house almost as if its construction were an act of leisure. "I made no haste in my work," he would later remark, "but rather made the most of it." He laid the foundation for a chimney, framed and raised the house, finished the outside walls, roof, and floor with the boards of an old shanty he had purchased from a laborer on the nearby railroad, dug his cellar in the side of a hill where a woodchuck had formerly dug his burrow, and moved in on the Fourth of July—America's and, ultimately, Thoreau's own "Independence Day."

When *Walden* appeared in 1854, the book met with mixed reviews. It was predictable, perhaps, that at the midpoint of the nineteenth century, when science, human invention, and industrialism all came together to form a new concept of progress in America, Thoreau's sojourn at Walden Pond would seem too dreamy and irresponsible to be considered in step with the advance of "modern" American culture. But in the century-and-a-half since Thoreau first took up residence there, Walden the place and *Walden* the book have come to hold dramatically different meanings for several generations. Walden Pond has taken on mythic dimensions that have literally made the Pond seem larger than life. So large has Walden Pond become in the popular imagination that one occasionally hears an audible gasp from those who see it for the first time—"It's much smaller than I imagined," they say somewhat under their breath. For some of the more than 700,000 people who visit it annually and describe their visit as a pilgrimage, the Pond evidently serves as a holy site. And as for *Walden*: It is now possibly the single most-read book by an American writer. *Walden's* meaning and its messages—for surely there is no one message that anyone takes from this book—have been appropriated by environmentalists and land preservationists; by poets and artists, peace advocates, civil and religious reformers; and most of all by those who continue to aspire after Thoreau's ideal life, a life lived "deliberately."

Ronald A. Bosco
Concord, Massachusetts
March 1, 2002

ARTIST'S INTRODUCTION

As in other parts of life, the most important part of photography is attitude. By attitude I mean expectation. You cannot hike ten miles or drive a hundred and expect to see anything unless you are prepared to see something wonderful. Your eyes simply won't notice.

I first photographed when I was in grade school, with nothing particular to show for it. Later I made vacation photos with an occasional attempt at something artistic. In my mid-thirties, I decided to try photographing seriously. An engineer by training, I had no problems technically; the images were properly exposed and in focus. But my pictures were as literal as my seeing.

We must learn to reawaken and keep ourselves awake, not by mechanical aids, but by an infinite expectation of the dawn, which does not forsake us in our soundest sleep. I know of no more encouraging fact than the unquestionable ability of man to elevate his life by conscious endeavor. It is something to be able to paint a particular picture, or to carve a statue, and so to make a few objects beautiful; but it is far more glorious to carve and paint the very atmosphere and medium through which we look, which morally we can do.

The "atmosphere and medium" I needed to make the pictures I had anticipated but had not seen was forced upon me by springtime in New England, when maple trees produce buds in a variety of colors centering on crimson, all easily as beautiful as their leaves in the fall. The red maple sends out flowers, fruits, and shoots in scarlet hues. Entire forests turn shades of red mixed with the muted tones contributed by oaks, birches, and beeches. Seen during an early morning drive heading east, the sides of the road become a fairyland: an ensemble of millions of buds and flowers glowing like a dreamed Christmas. Without realizing it at the time, I had joined Thoreau, for I now had the "expectation of the dawn."

Then, in 1991, my wife's colleagues in the Massachusetts Department of Environmental Management suggested I visit Walden. At first sight Walden Pond holds no unusual beauty. It is the bottom of a kettle hole from the last ice age, quite deep and of a modest sixty-one or so acres (25ha). It is surrounded by a heavily traveled hiking path and receives nearly three-quarters of a million visitors each year.

I have always felt that my real introduction to Walden happened on October 19, 1991, on a sunny afternoon when I first noticed Wyman's Meadow, the marsh along the hiking path about three hundred feet (483km) from the site of Thoreau's cabin. It is wet year-round and often supports a growth of water shields, a cousin of the water lily. At first glance it seemed uninteresting except for a few glimmers of colored reflections among the water-shields. I placed my tripod at the water's edge and pointed my camera down into the water. Some of the images that resulted from that afternoon are on the cover of this volume and on pages 59 and 90. I was hooked. The unexpected richness of this marsh elevated my experience and expectation of all of Walden and yielded many more images through all the seasons.

My discovery of the text of *Walden* had to wait for the knowledgeable and perceptive editing of Ronald A. Bosco. When my perpetually racing mind settled on the excerpts, and as I proceeded to match images with the text, I discovered a perspective of infinite richness, one I had never extracted from the longer text. But the perspective was, surprisingly, not entirely new. I felt that my twenty-five years of noticing, seeing, and photographing had touched on Thoreau's own search, and that each time I made an image I carved the atmosphere and enabled myself to see the grand landscape of a small marsh or a few roots.

John Wawrzonek
Southborough, Massachusetts
March 1, 2002

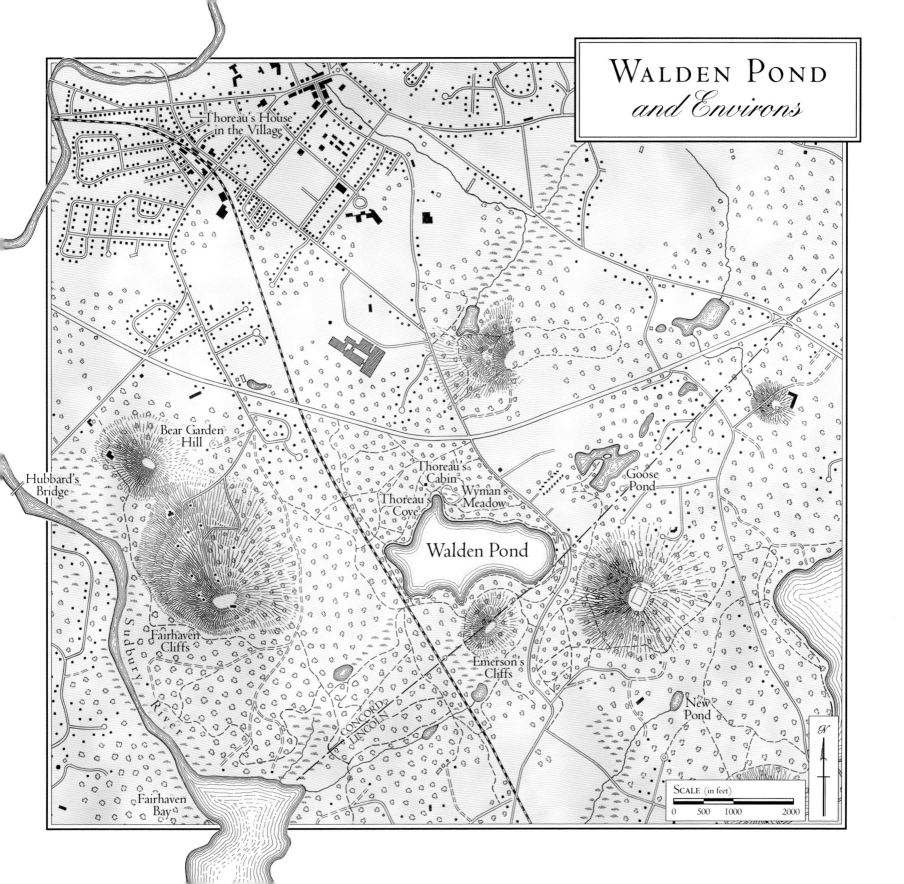

Economy

WHEN I WROTE THE FOLLOWING PAGES, or rather the bulk of them, I lived alone, in the woods, a mile from any neighbor, in a house which I had built myself, on the shore of Walden Pond, in Concord, Massachusetts, and earned my living by the labor of my hands only. I lived there two years and two months.

Thoreau's Cove

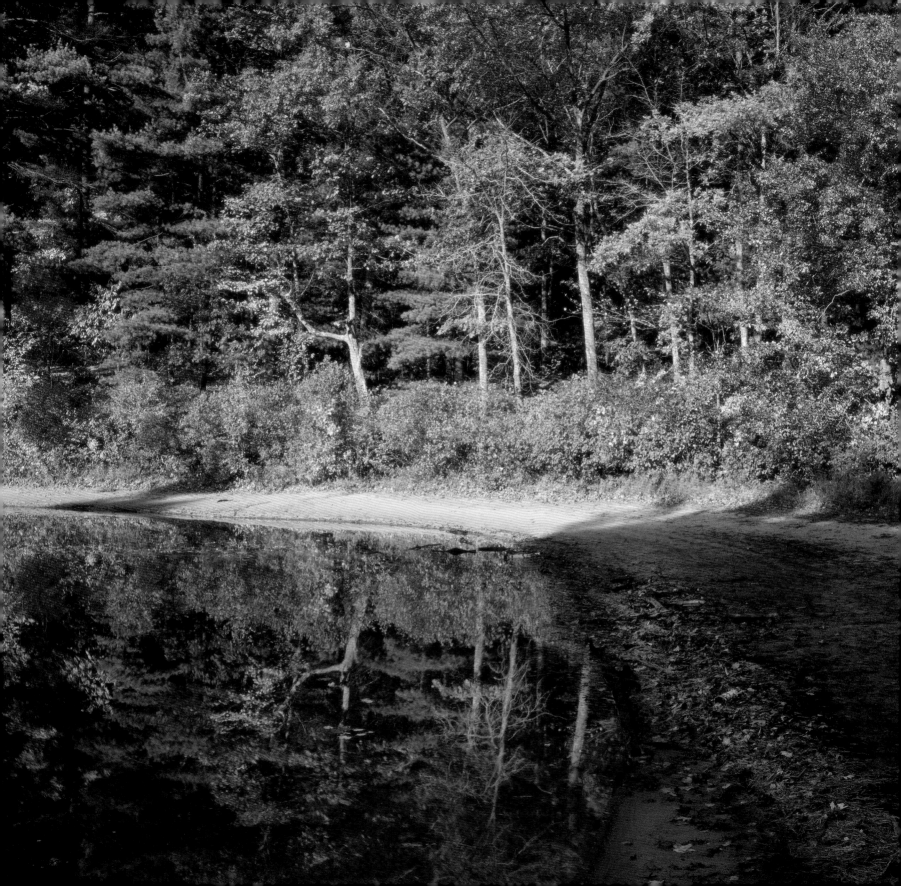

THE MASS OF MEN LEAD LIVES OF QUIET DESPERATION. What is called resignation is confirmed desperation. From the desperate city you go into the desperate country, and have to console yourself with the bravery of minks and muskrats. A stereotyped but unconscious despair is concealed even under what are called the games and amusements of mankind. There is no play in them, for this comes after work. But it is a characteristic of wisdom not to do desperate things.

When we consider what, to use the words of the catechism, is the chief end of man, and what are the true necessities and means of life, it appears as if men had deliberately chosen the common mode of living because they preferred it to any other. Yet they honestly think there is no choice left. But alert and healthy natures remember that the sun rose clear.

Thoreau's Cove

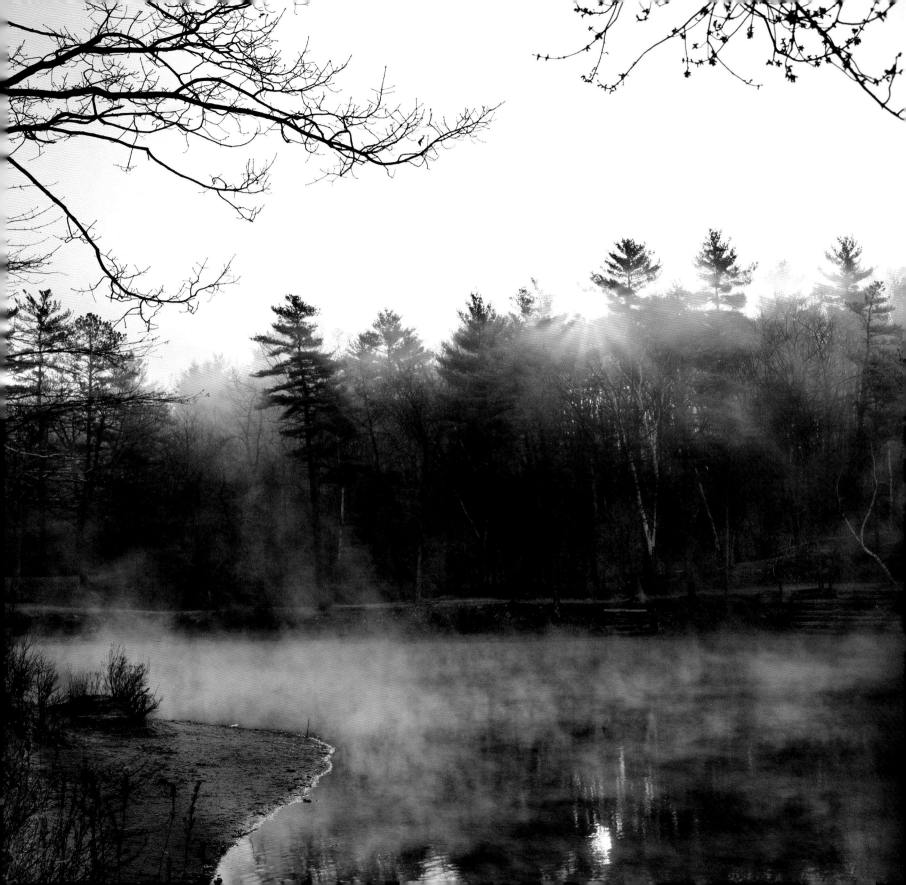

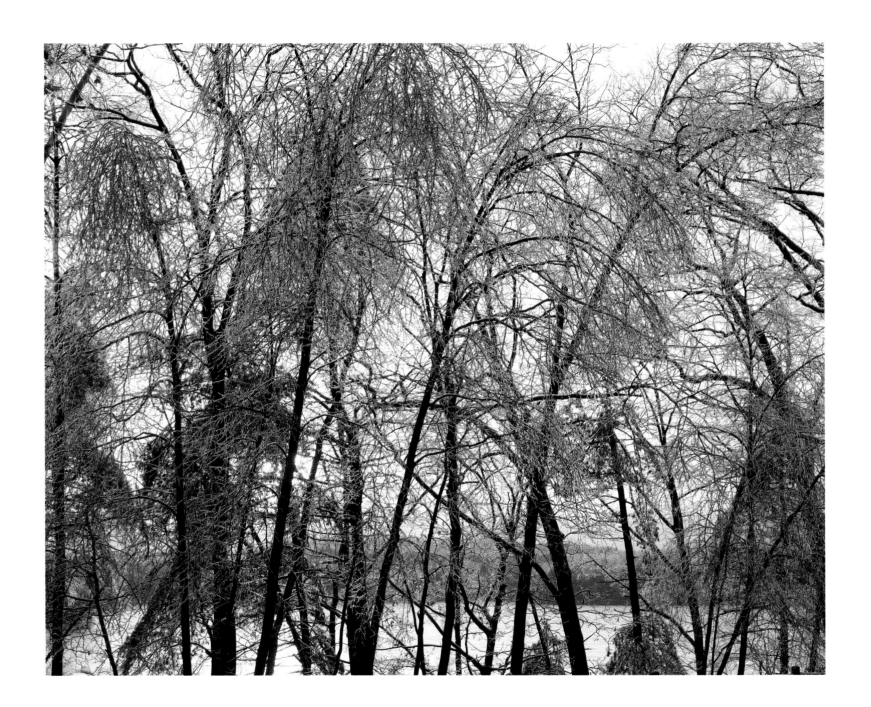

WE MIGHT TRY OUR LIVES BY A THOUSAND SIMPLE TESTS; as, for instance, that the same sun which ripens my beans illumines at once a system of earths like ours. If I had remembered this it would have prevented some mistakes. This was not the light in which I hoed them. The stars are the apexes of what wonderful triangles! What distant and different beings in the various mansions of the universe are contemplating the same one at the same moment! Nature and human life are as various as our several constitutions. Who shall say what prospect life offers to another? Could a greater miracle take place than for us to look through each other's eyes for an instant? We should live in all the ages of the world in an hour; ay, in all the worlds of the ages. History, Poetry, Mythology!—I know of no reading of another's experience so startling and informing as this would be.

Walden Pond

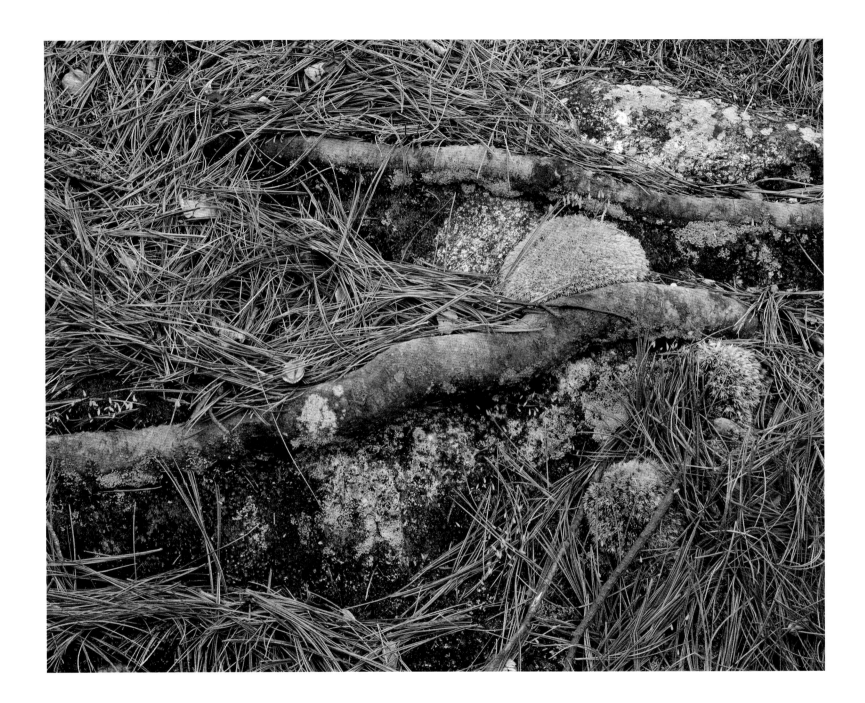

WHEN A MAN IS WARMED . . . what does he want next? Surely not more warmth of the same kind, as more and richer food, larger and more splendid houses, finer and more abundant clothing, more numerous incessant and hotter fires, and the like. When he has obtained those things which are necessary to life, there is another alternative than to obtain the superfluities; and that is, to adventure on life now, his vacation from humbler toil having commenced. The soil, it appears, is suited to the seed, for it has sent its radicle downward, and it may now send its shoot upward also with confidence. Why has man rooted himself thus firmly in the earth, but that he may rise in the same proportion into the heavens above?—for the nobler plants are valued for the fruit they bear at last in the air and light, far from the ground, and are not treated like the humbler esculents, which, though they may be biennials, are cultivated only till they have perfected their root, and often cut down at top for this purpose, so that most would not know them in their flowering season.

Southern Shore, Walden Pond

I LONG AGO LOST A HOUND, a bay horse, and a turtle-dove, and am still on their trail. Many are the travellers I have spoken concerning them, describing their tracks and what calls they answered to. I have met one or two who had heard the hound, and the tramp of the horse, and even seen the dove disappear behind a cloud, and they seemed as anxious to recover them as if they had lost them themselves.

Near Thoreau's Cabin Site

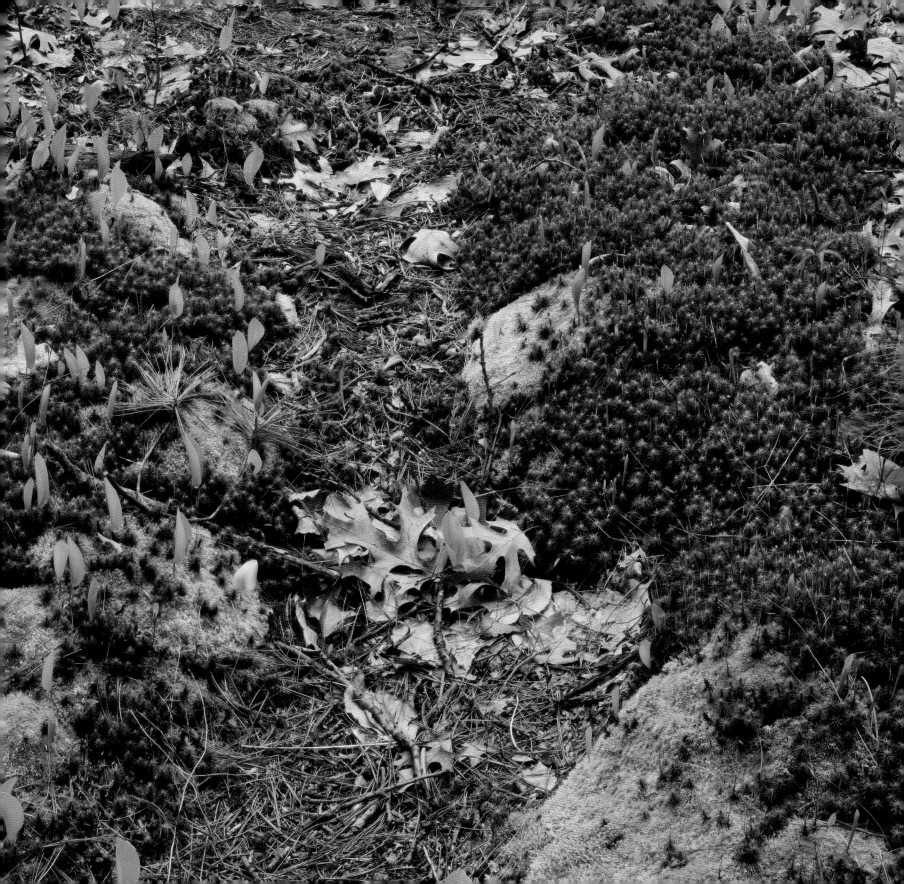

TO ANTICIPATE, not the sunrise and the dawn merely, but, if possible, Nature herself! How many mornings, summer and winter, before yet any neighbor was stirring about his business, have I been about mine! No doubt, many of my townsmen have met me returning from this enterprise, farmers starting for Boston in the twilight, or woodchoppers going to their work. It is true, I never assisted the sun materially in his rising, but, doubt not, it was of the last importance only to be present at it.

Walden Pond, facing east

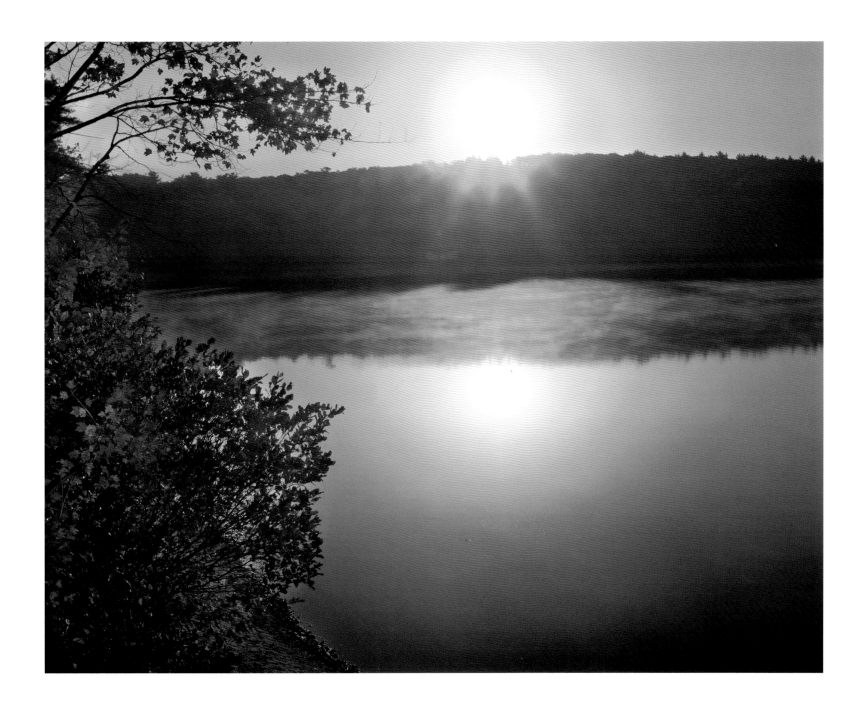

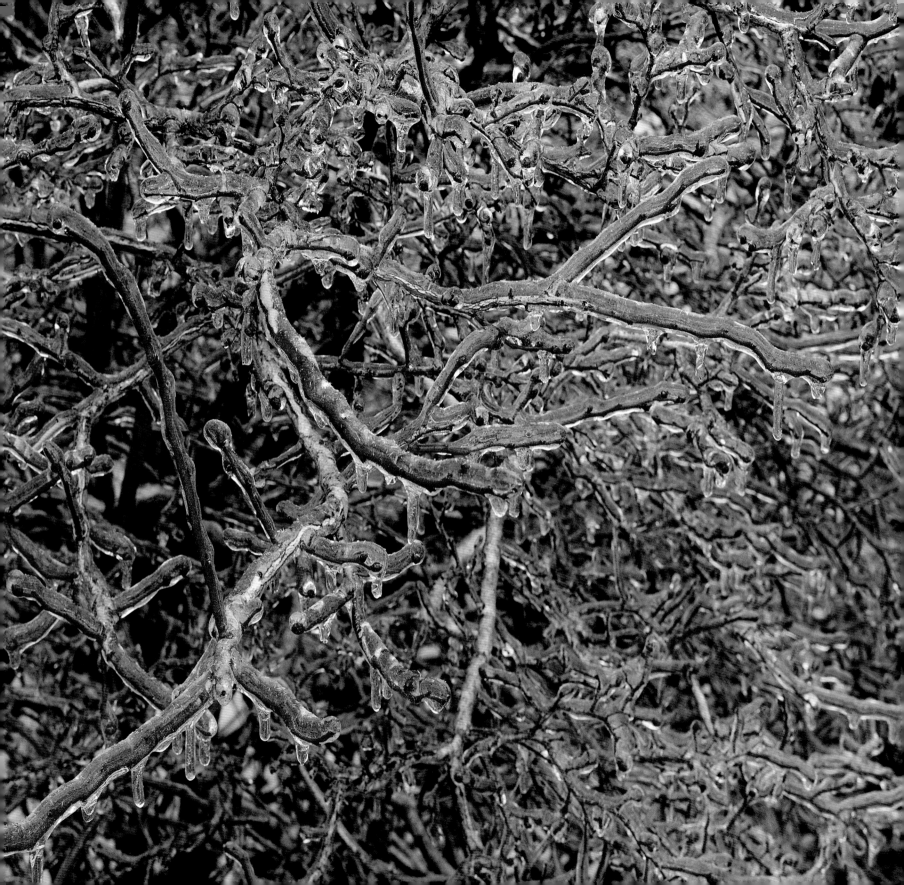

MAN WAS NOT MADE SO LARGE LIMBED and robust but that he must
seek to narrow his world, and wall in a space such as fitted him.
He was at first bare and out of doors; but though this was pleas-
ant enough in serene and warm weather, by daylight, the rainy
season and the winter, to say nothing of the torrid sun, would
perhaps have nipped his race in the bud if he had not made haste
to clothe himself with the shelter of a house. Adam and Eve,
according to the fable, wore the bower before other clothes.

Near Wyman's Meadow

NEAR THE END OF MARCH, 1845, I borrowed an axe and went down to the woods by Walden Pond, nearest to where I intended to build my house, and began to cut down some tall arrowy white pines, still in their youth, for timber. It is difficult to begin without borrowing, but perhaps it is the most generous course thus to permit your fellow-men to have an interest in your enterprise. . . . It was a pleasant hillside where I worked, covered with pine woods, through which I looked out on the pond, and a small open field in the woods where pines and hickories were springing up. The ice in the pond was not yet dissolved, though there were some open spaces, and it was all dark colored and saturated with water. There were some slight flurries of snow during the days that I worked there; but for the most part when I came out on to the railroad, on my way home, its yellow sand heap stretched away gleaming in the hazy atmosphere, and the rails shone in the spring sun, and I heard the lark and pewee and other birds already come to commence another year with us. They were pleasant spring days, in which the winter of man's discontent was thawing as well as the earth, and the life that had lain torpid began to stretch itself.

Walden Pond, facing south

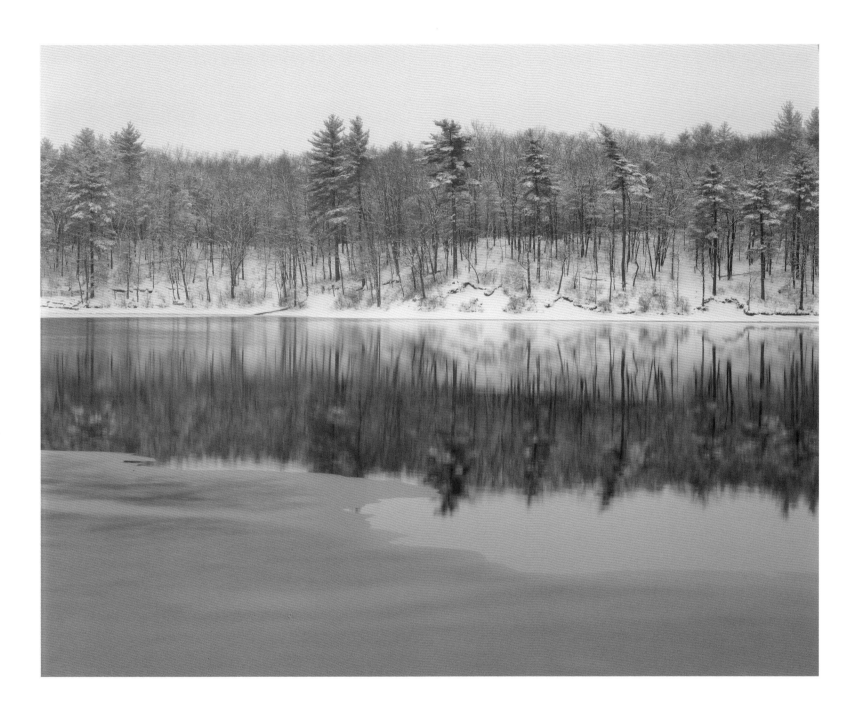

Where I Lived, and What I Lived For

AT A CERTAIN SEASON OF OUR LIFE we are accustomed to consider every spot as the possible site of a house. I have thus surveyed the country on every side within a dozen miles of where I live. In imagination I have bought all the farms in succession, for all were to be bought, and I knew their price. I walked over each farmer's premises, tasted his wild apples, discoursed on husbandry with him, took his farm at his price, at any price, mortgaging it to him in my mind; even put a higher price on it,—took every thing but a deed of it,—took his word for his deed, for I dearly love to talk,—cultivated it, and him too to some extent, I trust, and withdrew when I had enjoyed it long enough, leaving him to carry it on. This experience entitled me to be regarded as a sort of real-estate broker by my friends. Wherever I sat, there I might live, and the landscape radiated from me accordingly.

Thoreau's Cove

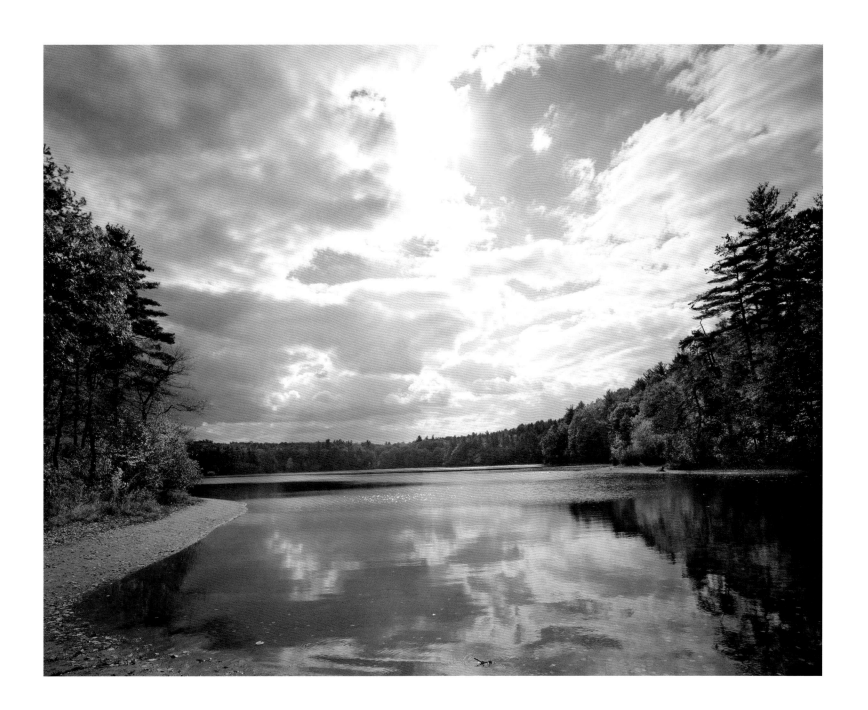

EVERY MORNING WAS A CHEERFUL INVITATION to make my life of equal simplicity, and I may say innocence, with Nature herself. I have been as sincere a worshipper of Aurora as the Greeks. I got up early and bathed in the pond; that was a religious exercise, and one of the best things which I did. They say that characters were engraven on the bathing tub of king Tching-thang to this effect: "Renew thyself completely each day; do it again, and again, and forever again." I can understand that. Morning brings back the heroic ages. . . . The morning, which is the most memorable season of the day, is the awakening hour. Then there is least somnolence in us; and for an hour, at least, some part of us awakes which slumbers all the rest of the day and night. Little is to be expected of that day, if it can be called a day, to which we are not awakened by our Genius, but by the mechanical nudgings of some servitor, are not awakened by our own newly-acquired force and aspirations from within, accompanied by the undulations of celestial music, instead of factory bells, and a fragrance filling the air—to a higher life than we fell asleep from; and thus the darkness bear its fruit, and prove itself to be good, no less than the light. That man who does not believe that each day contains an earlier, more sacred, and auroral hour than he has yet profaned,

has despaired of life, and is pursuing a descending and darkening way. After a partial cessation of his sensuous life, the soul of man, or its organs rather, are reinvigorated each day, and his Genius tries again what noble life it can make. . . . Poetry and art, and the fairest and most memorable of the actions of men, date from such an hour. All poets and heroes, like Memnon, are the children of Aurora, and emit their music at sunrise. To him whose elastic and vigorous thought keeps pace with the sun, the day is a perpetual morning. It matters not what the clocks say or the attitudes and labors of men. Morning is when I am awake and there is a dawn in me. . . .

We must learn to reawaken and keep ourselves awake, not by mechanical aids, but by an infinite expectation of the dawn, which does not forsake us in our soundest sleep. I know of no more encouraging fact than the unquestionable ability of man to elevate his life by a conscious endeavor. It is something to be able to paint a particular picture, or to carve a statue, and so to make a few objects beautiful; but it is far more glorious to carve and paint the very atmosphere and medium through which we look, which morally we can do.

I WENT TO THE WOODS BECAUSE I WISHED TO LIVE DELIBERATELY, to
front only the essential facts of life, and see if I could not learn
what it had to teach, and not, when I came to die, discover that I
had not lived. I did not wish to live what was not life, living is so
dear; nor did I wish to practice resignation, unless it was quite
necessary. I wanted to live deep and suck out all the marrow of
life, to live so sturdily and Spartan-like as to put to rout all that
was not life, to cut a broad swath and shave close, to drive life
into a corner, and reduce it to its lowest terms, and, if it proved
to be mean, why then to get the whole and genuine meanness of
it, and publish its meanness to the world; or if it were sublime,
to know it by experience, and be able to give a true account of it
in my next excursion. For most men, it appears to me, are in a
strange uncertainty about it, whether it is of the devil or of God,
and have somewhat hastily concluded that it is the chief end of
man here to "glorify God and enjoy him forever."

Near Thoreau's Cabin Site

SIMPLICITY, SIMPLICITY, SIMPLICITY! I say, let your affairs be as two or three, and not a hundred or a thousand; instead of a million count half a dozen, and keep your accounts on your thumb nail. In the midst of this chopping sea of civilized life, such are the clouds and storms and quicksands and thousand-and-one items to be allowed for, that a man has to live, if he would not founder and go to the bottom and not make his port at all, by dead reckoning, and he must be a great calculator indeed who succeeds. Simplify, simplify.

Wyman's Meadow

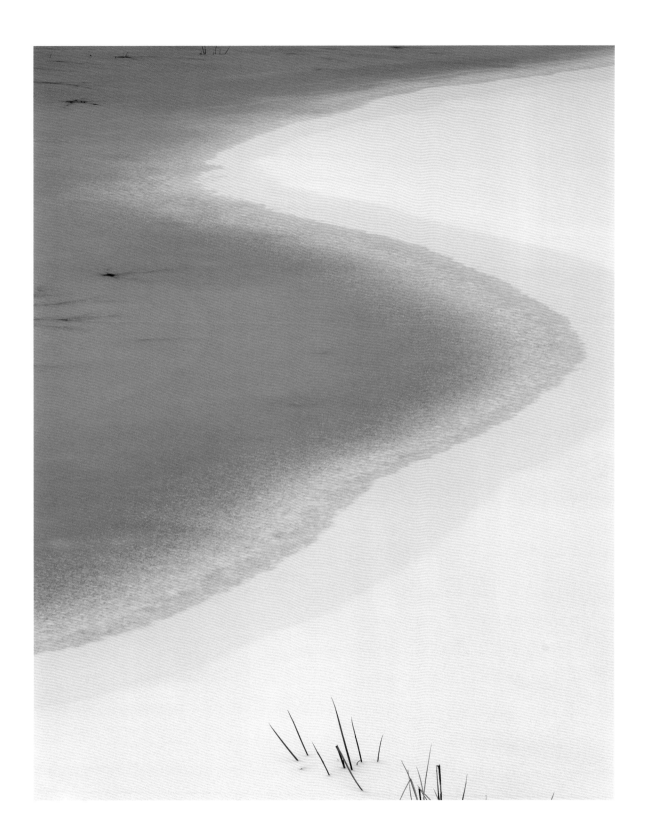

TIME IS BUT THE STREAM I GO A-FISHING IN. I drink at it; but while I drink I see the sandy bottom and detect how shallow it is. Its thin current slides away, but eternity remains. I would drink deeper; fish in the sky, whose bottom is pebbly with stars. I cannot count one. I know not the first letter of the alphabet. I have always been regretting that I was not as wise as the day I was born. The intellect is a cleaver; it discerns and rifts its way into the secret of things. I do not wish to be any more busy with my hands than is necessary. My head is hands and feet. I feel all my best faculties concentrated in it. My instinct tells me that my head is an organ for burrowing, as some creatures use their snout and fore-paws, and with it I would mine and burrow my way through these hills. I think that the richest vein is somewhere hereabouts; so by the divining rod and thin rising vapors I judge; and here I will begin to mine.

Walden Pond

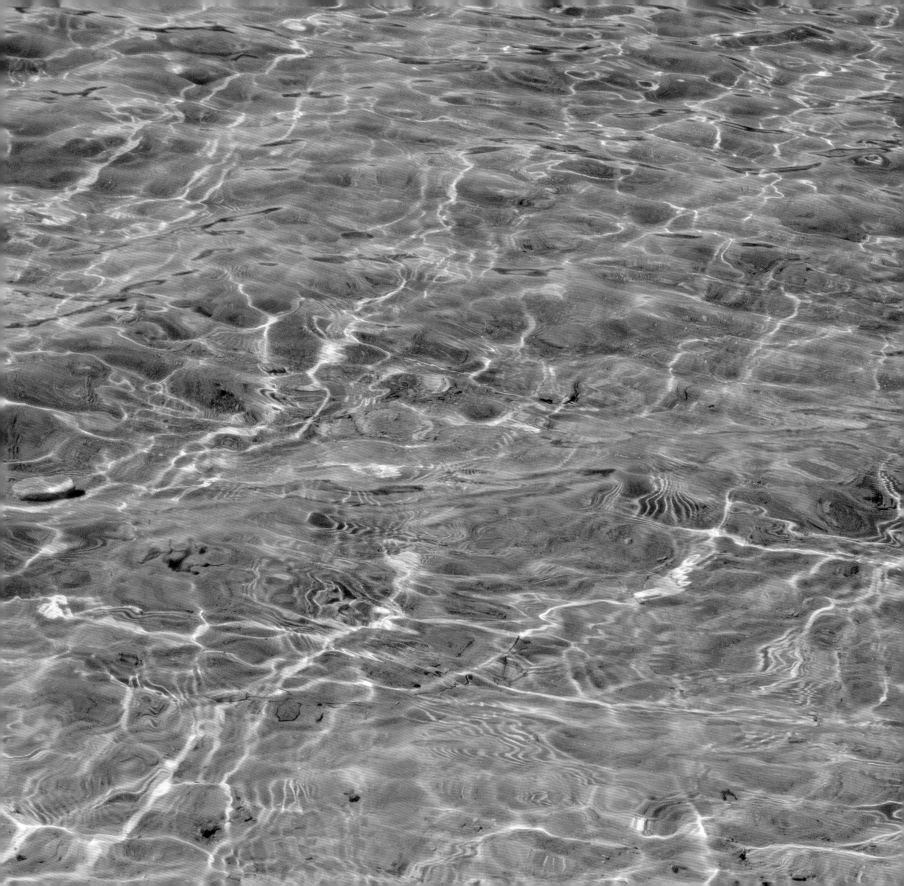

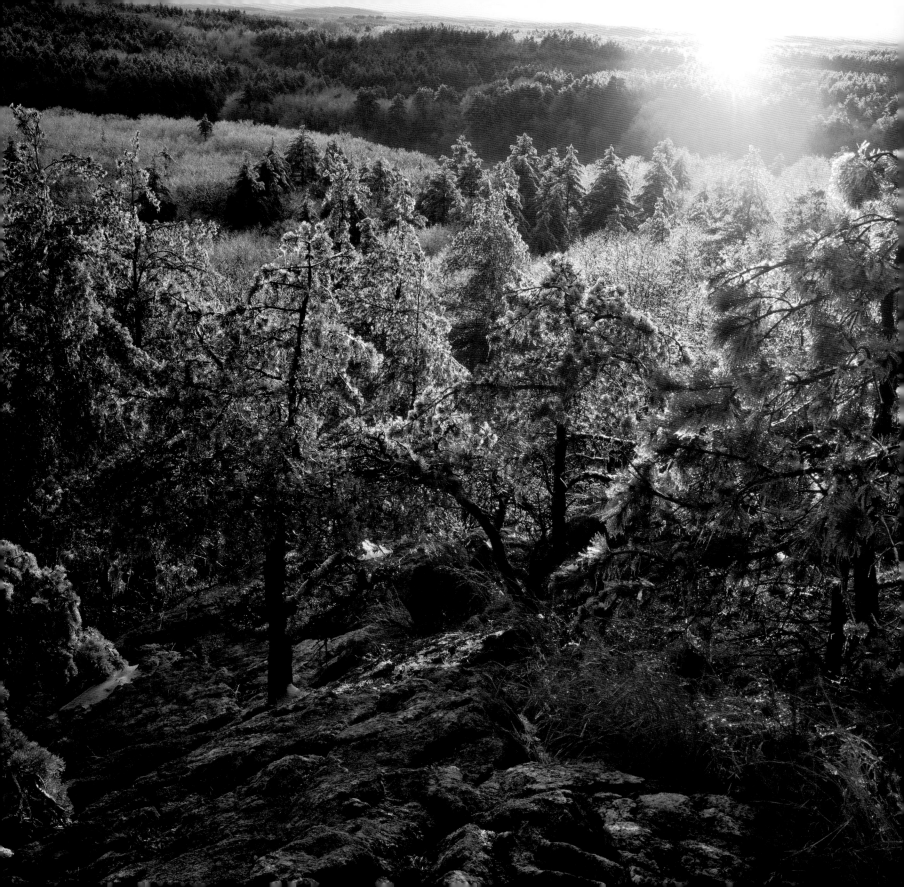

Reading

HOWEVER MUCH WE MAY ADMIRE the orator's occasional bursts of eloquence, the noblest written words are commonly as far behind or above the fleeting spoken language as the firmament with its stars is behind the clouds. There are the stars, and they who can may read them. The astronomers forever comment on and observe them. They are not exhalations like our daily colloquies and vaporous breath. What is called eloquence in the forum is commonly found to be rhetoric in the study. The orator yields to the inspiration of a transient occasion, and speaks to the mob before him, to those who can hear him; but the writer, whose more equable life is his occasion, and who would be distracted by the event and the crowd which inspire the orator, speaks to the intellect and heart of mankind, to all in any age who can understand him.

From Fairhaven Cliffs

(overleaf) Wyman's Meadow

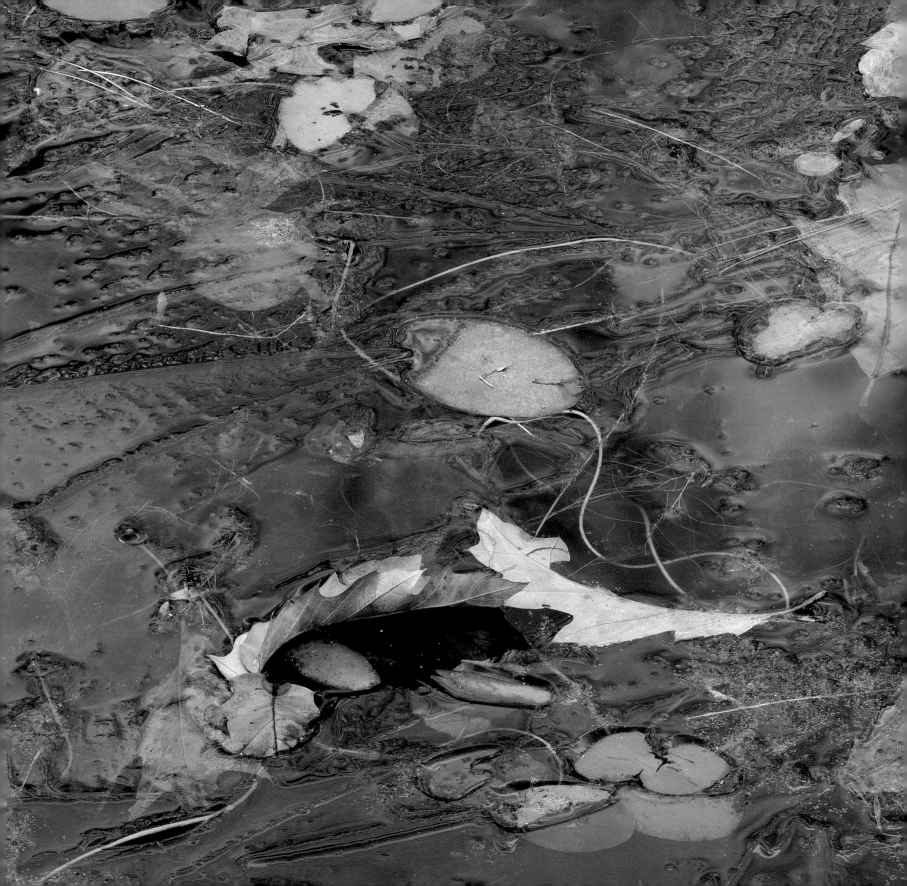

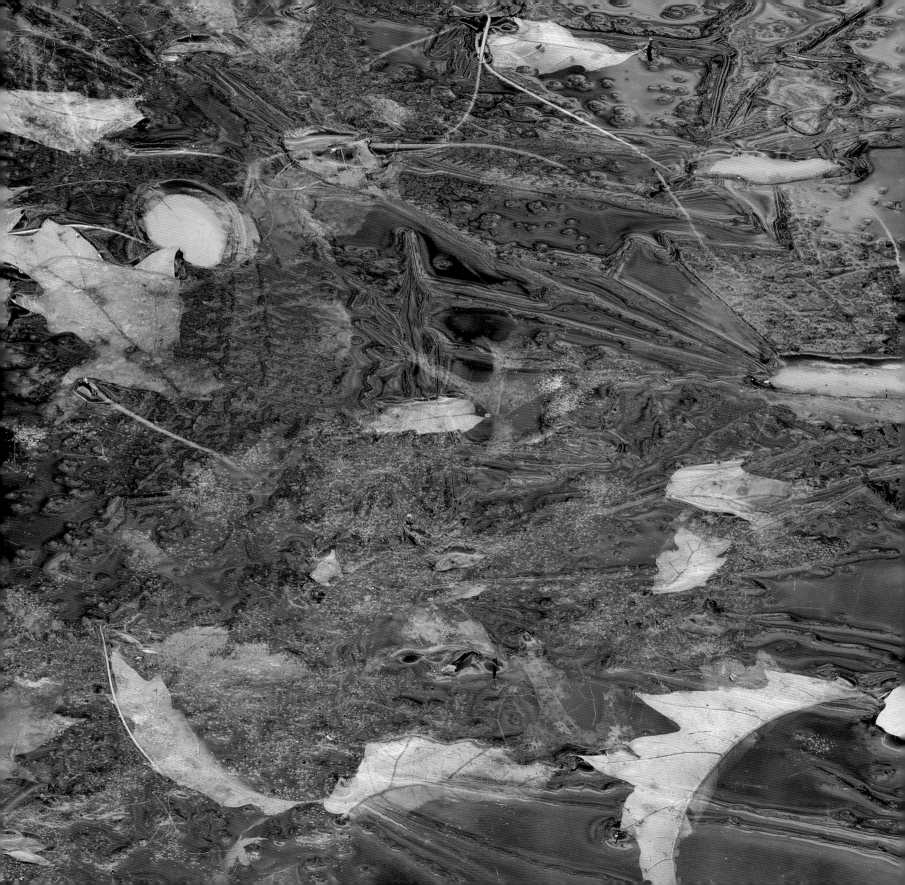

Sounds

I DID NOT READ BOOKS THE FIRST SUMMER; I hoed beans. Nay, I often did better than this. There were times when I could not afford to sacrifice the bloom of the present moment to any work, whether of the head or hands. I love a broad margin to my life. Sometimes, in a summer morning, having taken my accustomed bath, I sat in my sunny doorway from sunrise till noon, rapt in a revery, amidst the pines and hickories and sumachs, in undisturbed solitude and stillness, while the birds sang around or flitted noiseless through the house, until by the sun falling in at my west window, or the noise of some traveller's wagon on the distant highway, I was reminded of the lapse of time. I grew in those seasons like corn in the night, and they were far better than any work of the hands would have been. They were not time subtracted from my life, but so much over and above my usual allowance.

Near Thoreau's Cabin Site

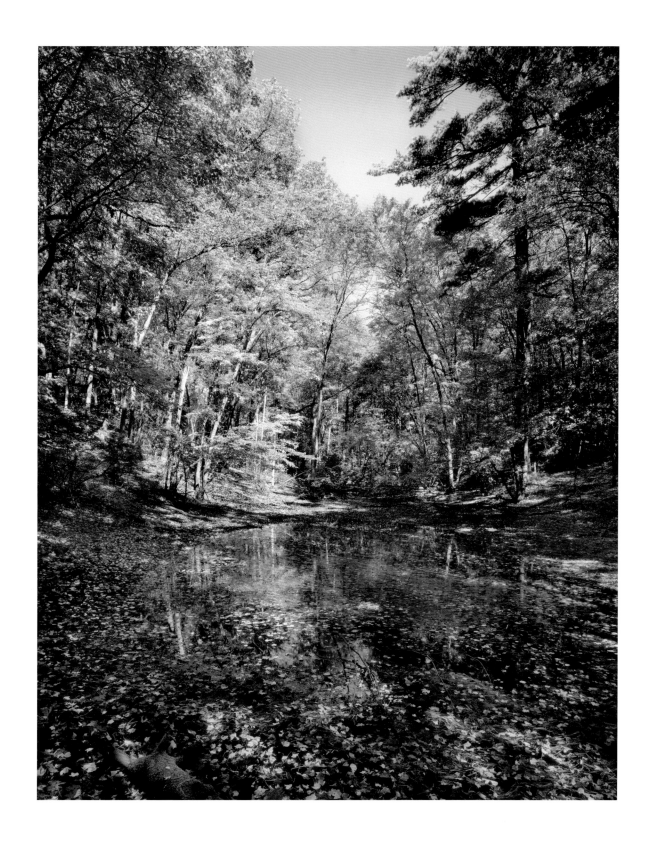

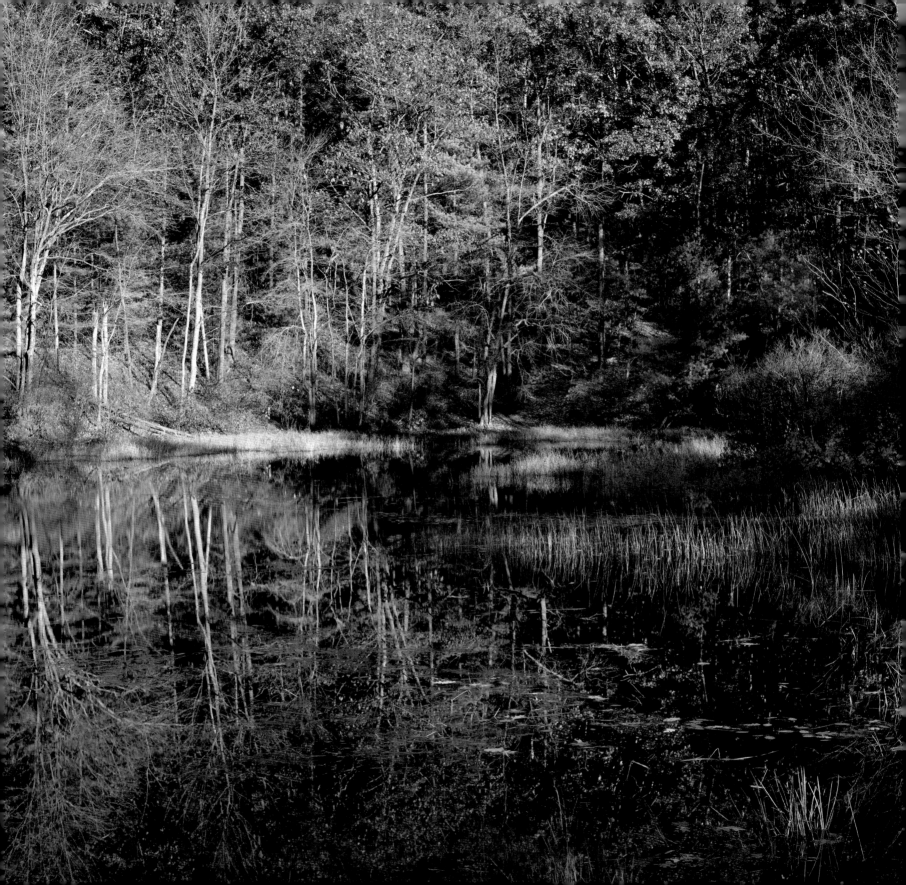

I HAD THIS ADVANTAGE, AT LEAST, in my mode of life, over those who were obliged to look abroad for amusement, to society and the theatre, that my life itself was become my amusement and never ceased to be novel. It was a drama of many scenes and without an end. If we were always indeed getting our living, and regulating our lives according to the last and best mode we had learned, we should never be troubled with ennui. Follow your genius closely enough, and it will not fail to show you a fresh prospect every hour.

Wyman's Meadow

MY HOUSE WAS ON THE SIDE OF A HILL, immediately on the edge of the larger wood, in the midst of a young forest of pitch pines and hickories, and half a dozen rods from the pond, to which a narrow footpath led down the hill. In my front yard grew the strawberry, blackberry, and life-everlasting, johnswort and golden-rod, shrub-oaks and sand-cherry, blueberry and groundnut. Near the end of May, the sand-cherry, (cerasus pumila,) adorned the sides of the path with its delicate flowers arranged in umbels cylindrically about its short stems, which last, in the fall, weighed down with good sized and handsome cherries, fell over in wreaths like rays on every side. I tasted them out of compliment to Nature, though they were scarcely palatable. The sumach, (rhus glabra,) grew luxuriantly about the house, pushing up through the embankment which I had made, and growing five or six feet the first season. Its broad pinnate tropical leaf was pleasant though strange to look on. The large buds, suddenly pushing out late in the spring from dry sticks which had seemed to be dead, developed themselves as by magic into graceful green and tender boughs, an inch in diameter; and sometimes, as I sat at my window, so heedlessly did they grow and tax their weak joints, I heard a fresh and tender bough suddenly fall like a fan to the ground, when there was not a breath of air stirring, broken off by its own weight. In August, the large masses of berries, which, when in flower, had attracted many wild bees, gradually assumed their bright velvety crimson hue, and by their weight again bent down and broke the tender limbs.

South of Walden Pond

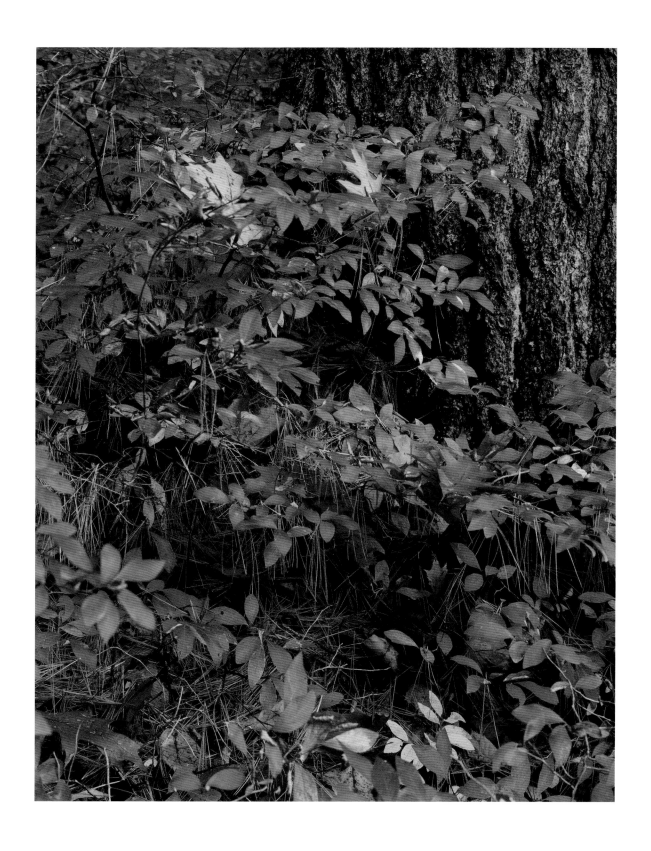

SOMETIMES, ON SUNDAYS, I HEARD THE BELLS, the Lincoln, Acton, Bedford, or Concord bell, when the wind was favorable, a faint, sweet, and, as it were, natural melody, worth importing into the wilderness. At a sufficient distance over the woods this sound acquires a certain vibratory hum, as if the pine needles in the horizon were the strings of a harp which it swept. All sound heard at the greatest possible distance produces one and the same effect, a vibration of the universal lyre, just as the intervening atmosphere makes a distant ridge of earth interesting to our eyes by the azure tint it imparts to it. There came to me in this case a melody which the air had strained, and which had conversed with every leaf and needle of the wood, that portion of the sound which the elements had taken up and modulated and echoed from vale to vale. The echo is, to some extent, an original sound, and therein is the magic and charm of it. It is not merely a repetition of what was worth repeating in the bell, but partly the voice of the wood; the same trivial words and notes sung by a wood-nymph.

From Fairhaven Cliffs

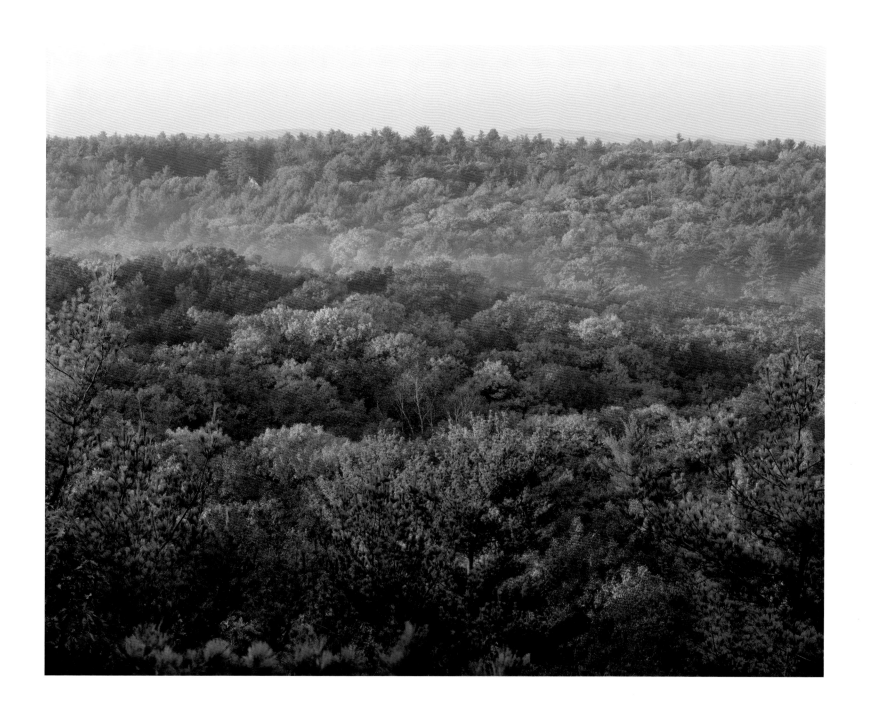

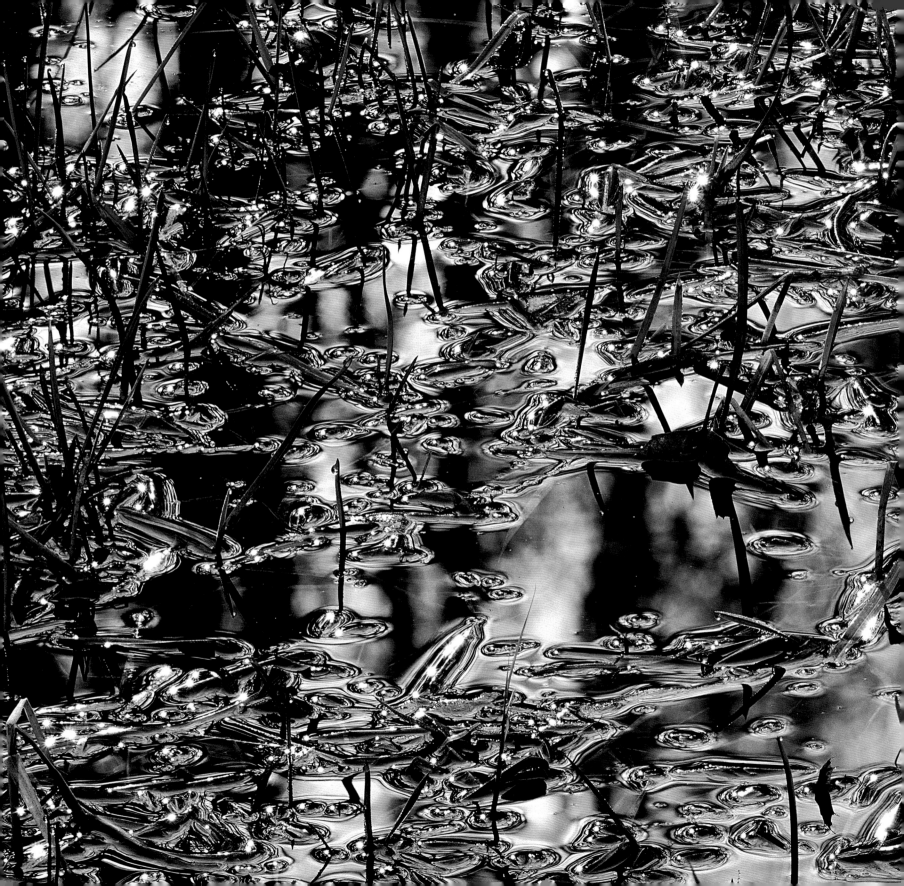

I REJOICE THAT THERE ARE OWLS. Let them do the idiotic and maniacal hooting for men. It is a sound admirably suited to swamps and twilight woods which no day illustrates, suggesting a vast and undeveloped nature which men have not recognized. They represent the stark twilight and unsatisfied thoughts which all have. All day the sun has shone on the surface of some savage swamp, where the single spruce stands hung with usnea lichens, and small hawks circulate above, and the chicadee lisps amid the evergreens, and the partridge and rabbit skulk beneath; but now a more dismal and fitting day dawns, and a different race of creatures awakes to express the meaning of Nature there.

Wyman's Meadow

Solitude

THIS IS A DELICIOUS EVENING, when the whole body is one sense, and imbibes delight through every pore. I go and come with a strange liberty in Nature, a part of herself. As I walk along the stony shore of the pond in my shirt sleeves, though it is cool as well as cloudy and windy, and I see nothing special to attract me, all the elements are unusually congenial to me. The bullfrogs trump to usher in the night, and the note of the whippoorwill is borne on the rippling wind from over the water. Sympathy with the fluttering alder and poplar leaves almost takes away my breath; yet, like the lake, my serenity is rippled but not ruffled. These small waves raised by the evening wind are as remote from storm as the smooth reflecting surface. Though it is now dark, the wind still blows and roars in the wood, the waves still dash, and some creatures lull the rest with their notes. The repose is never complete. The wildest animals do not repose, but seek their prey now; the fox, and skunk, and rabbit, now roam the fields and woods without fear. They are Nature's watchmen,—links which connect the days of animated life.

Walden Pond

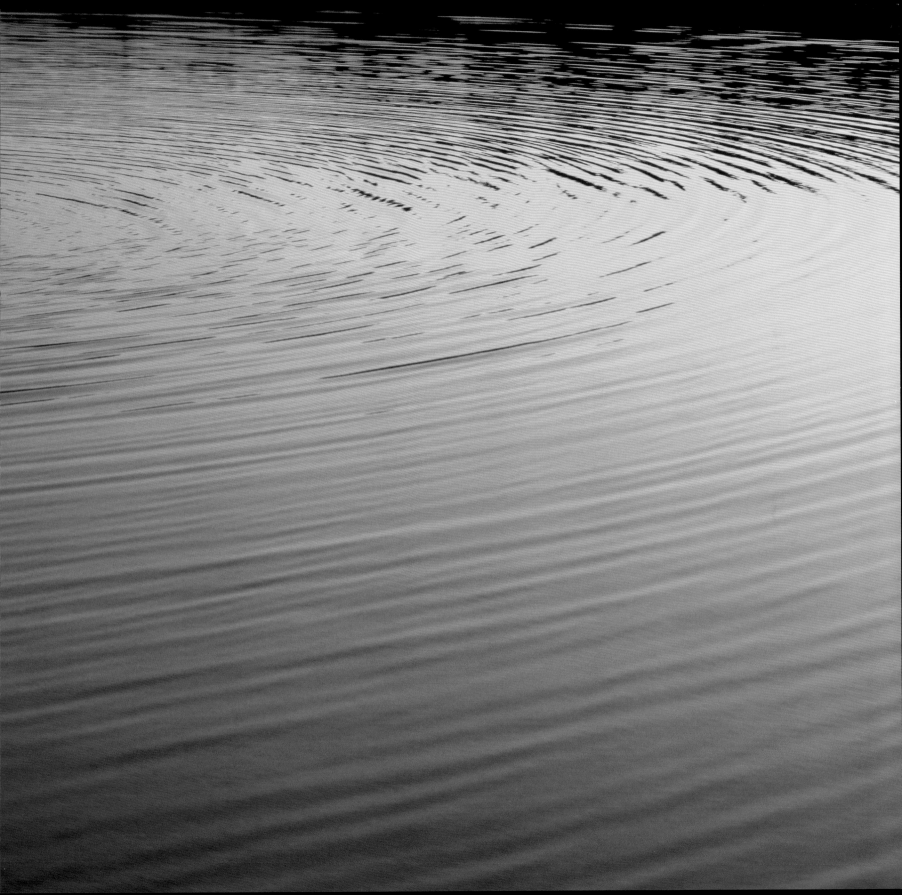

YET I EXPERIENCED SOMETIMES that the most sweet and tender, the most innocent and encouraging society may be found in any natural object, even for the poor misanthrope and most melancholy man. There can be no very black melancholy to him who lives in the midst of Nature and has his senses still. There was never yet such a storm but it was Æolian music to a healthy and innocent ear. Nothing can rightly compel a simple and brave man to a vulgar sadness. While I enjoy the friendship of the seasons I trust that nothing can make life a burden to me. The gentle rain which waters my beans and keeps me in the house to-day is not drear and melancholy, but good for me too. . . . Sometimes, when I compare myself with other men, it seems as if I were more favored by the gods than they, beyond any deserts that I am conscious of; as if I had a warrant and surety at their hands which my fellows have not, and were especially guided and guarded. I do not flatter myself, but if it be possible they flatter me. I have never felt lonesome, or in the least oppressed by a sense of solitude, but once, and that was a few weeks after I came to the woods, when, for an hour, I doubted if the near neighborhood of

Wyman's Meadow

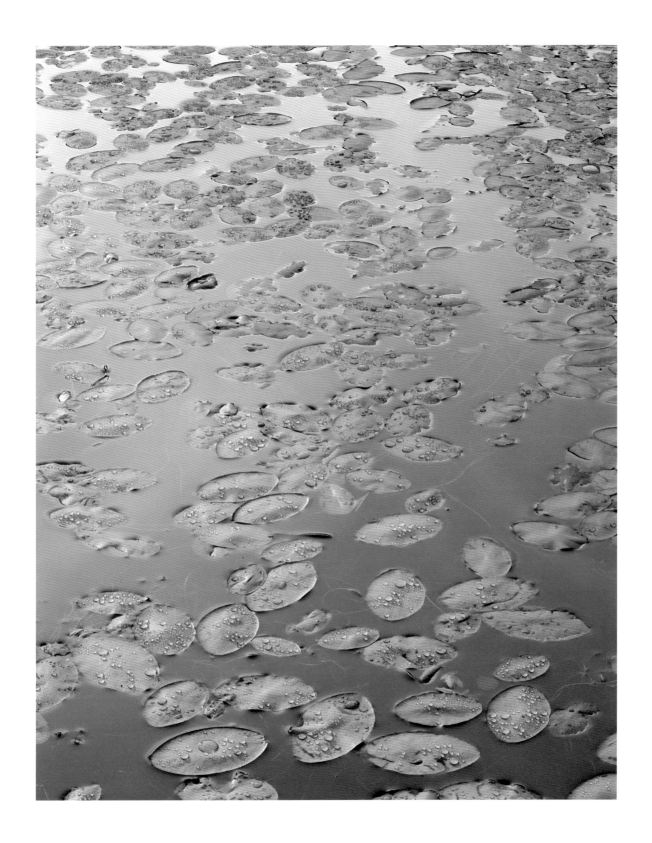

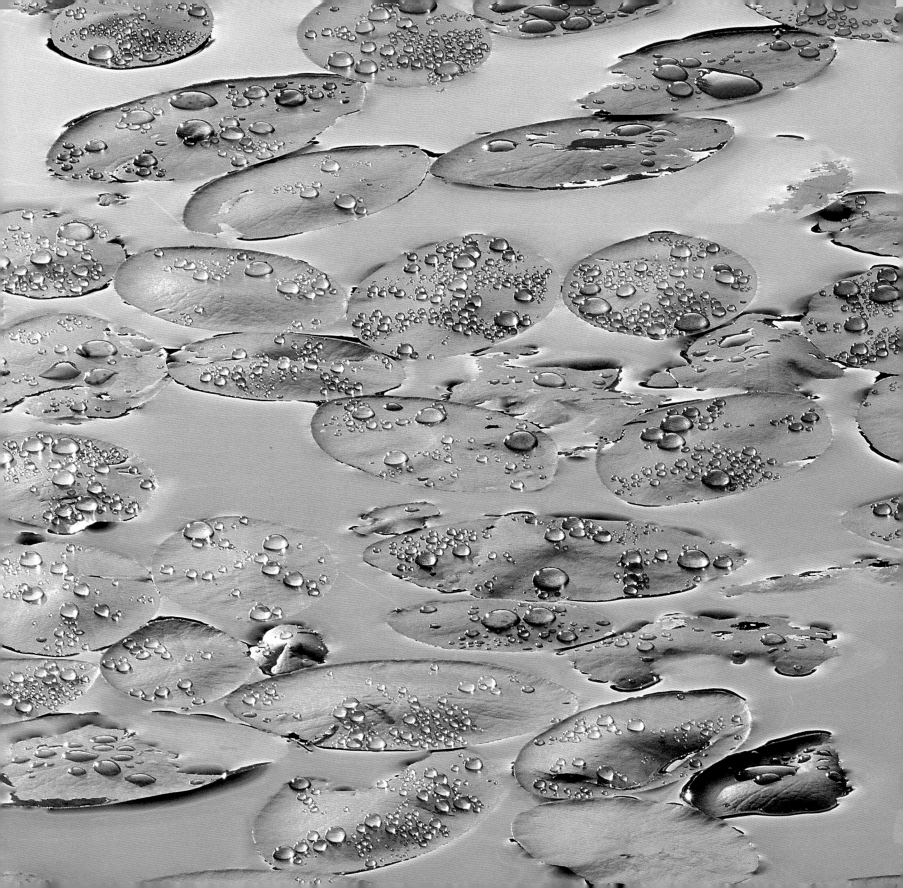

man was not essential to a serene and healthy life. To be alone was something unpleasant. But I was at the same time conscious of a slight insanity in my mood, and seemed to foresee my recovery. In the midst of a gentle rain while these thoughts prevailed, I was suddenly sensible of such sweet and beneficent society in Nature, in the very pattering of the drops, and in every sound and sight around my house, an infinite and unaccountable friendliness all at once like an atmosphere sustaining me, as made the fancied advantages of human neighborhood insignificant, and I have never thought of them since. Every little pine needle expanded and swelled with sympathy and befriended me. I was so distinctly made aware of the presence of something kindred to me, even in scenes which we are accustomed to call wild and dreary, and also that the nearest of blood to me and humanest was not a person nor a villager, that I thought no place could ever be strange to me again.

Wyman's Meadow (detail)

I HAVE A GREAT DEAL OF COMPANY in my house; especially in the morning, when nobody calls. Let me suggest a few comparisons, that some one may convey an idea of my situation. I am no more lonely than the loon in the pond that laughs so loud, or than Walden Pond itself. What company has that lonely lake, I pray? And yet it has not the blue devils, but the blue angels in it, in the azure tint of its waters. The sun is alone, except in thick weather, when there sometimes appear to be two, but one is a mock sun. God is alone,—but the devil, he is far from being alone; he sees a great deal of company; he is legion. I am no more lonely than a single mullein or dandelion in a pasture, or a bean leaf, or sorrel, or a horse-fly, or a humble-bee. I am no more lonely than the Mill Brook, or a weathercock, or the north star, or the south wind, or an April shower, or a January thaw, or the first spider in a new house.

Wyman's Meadow

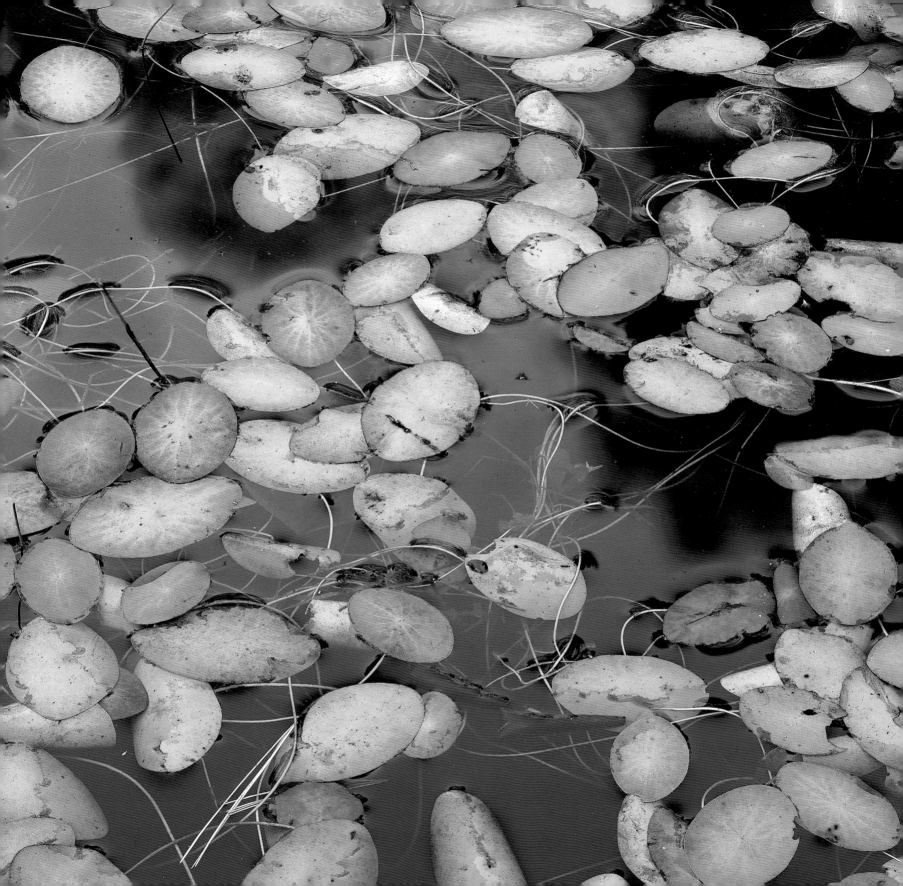

THE INDESCRIBABLE INNOCENCE and beneficence of Nature,—of sun and wind and rain, of summer and winter,—such health, such cheer, they afford forever! and such sympathy have they ever with our race, that all Nature would be affected, and the sun's brightness fade, and the winds would sigh humanely, and the clouds rain tears, and the woods shed their leaves and put on mourning in midsummer, if any man should ever for a just cause grieve. Shall I not have intelligence with the earth? Am I not partly leaves and vegetable mould myself?

Near Thoreau's Cabin Site

Visitors

ONE INCONVENIENCE I SOMETIMES experienced in so small a house, the difficulty of getting to a sufficient distance from my guest when we began to utter the big thoughts in big words. You want room for your thoughts to get into sailing trim and run a course or two before they make their port. The bullet of your thought must have overcome its lateral and ricochet motion and fallen into its last and steady course before it reaches the ear of the hearer, else it may plough out again through the side of his head. Also, our sentences wanted room to unfold and form their columns in the interval. Individuals, like nations, must have suitable broad and natural boundaries, even a considerable neutral ground, between them. I have found it a singular luxury to talk across the pond to a companion on the opposite side.

Walden Pond, facing west

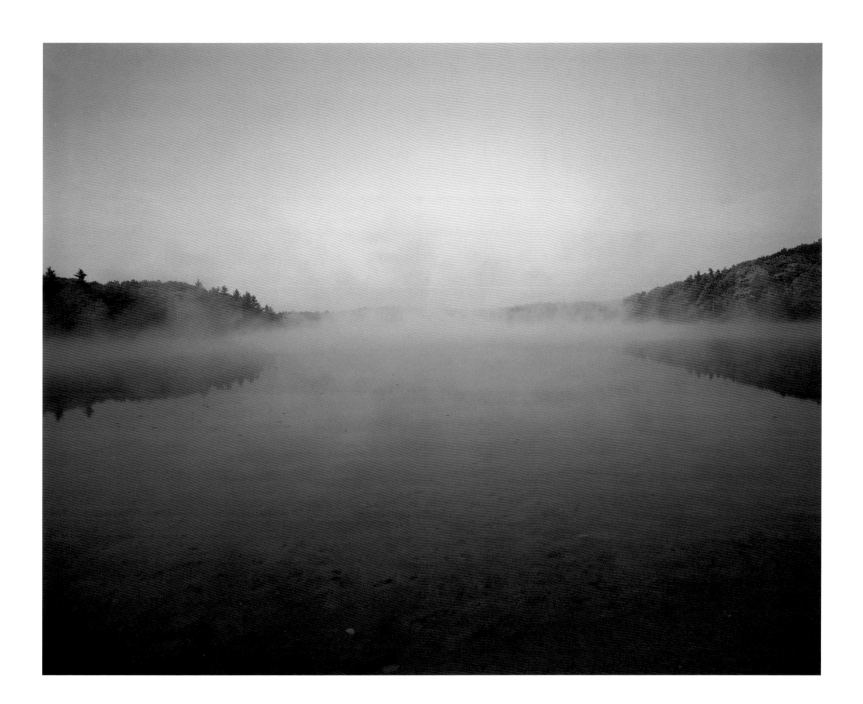

The Bean Field

THE NIGHT-HAWK CIRCLED OVERHEAD in the sunny afternoons—for I sometimes made a day of it—like a mote in the eye, or in heaven's eye, falling from time to time with a swoop and a sound as if the heavens were rent, torn at last to very rags and tatters, and yet a seamless cope remained; small imps that fill the air and lay their eggs on the ground on bare sand or rocks on the tops of hills, where few have found them; graceful and slender like ripples caught up from the pond, as leaves are raised by the wind to float in the heavens; such kindredship is in Nature. The hawk is aerial brother of the wave which he sails over and surveys, those his perfect air-inflated wings answering to the elemental unfledged pinions of the sea. Or sometimes I watched a pair of hen-hawks circling high in the sky, alternately soaring and descending, approaching and leaving one another, as if they were the imbodiment of my own thoughts. Or I was attracted by the passage of wild pigeons from this wood to that, with a slight quivering winnowing sound and carrier haste; or from under a rotten stump my hoe turned up a sluggish portentous and outlandish spotted salamander, a trace of Egypt and the Nile, yet our contemporary. When I paused to lean on my hoe, these sounds and sights I heard and saw any where in the row, a part of the inexhaustible entertainment which the country offers.

IT WAS A SINGULAR EXPERIENCE that long acquaintance which I cultivated with beans, what with planting, and hoeing, and harvesting, and threshing, and picking over, and selling them,—the last was the hardest of all,—I might add eating, for I did taste. I was determined to know beans. When they were growing, I used to hoe from five o'clock in the morning till noon, and commonly spent the rest of the day about other affairs. Consider the intimate and curious acquaintance one makes with various kinds of weeds,—it will bear some iteration in the account, for there was no little iteration in the labor,—disturbing their delicate organizations so ruthlessly, and making such invidious distinctions with his hoe, levelling whole ranks of one species, and sedulously cultivating another. That's Roman wormwood,—that's pigweed,—that's sorrel,—that's piper-grass,—have at him, chop him up, turn his roots upward to the sun, don't let him have a fibre in the shade, if you do he'll turn himself t'other side up and be as green as a leek in two days. A long war, not with cranes, but with weeds, those Trojans who had sun and rain and dews on their side. Daily the beans saw me come to their rescue armed with a hoe, and thin the ranks of their enemies, filling up the trenches with weedy dead. Many a lusty crest-waving Hector, that towered a whole foot above his crowding comrades, fell before my weapon and rolled in the dust.

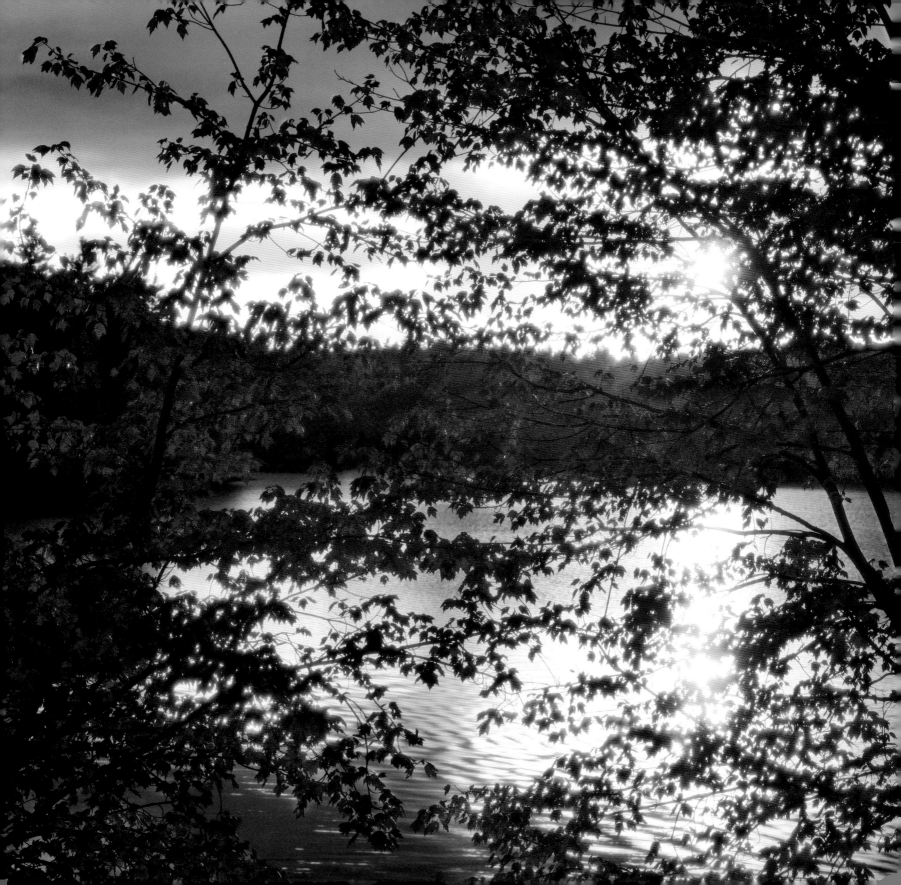

The Village

AFTER HOEING, or perhaps reading and writing, in the forenoon, I usually bathed again in the pond, swimming across one of its coves for a stint, and washed the dust of labor from my person, or smoothed out the last wrinkle which study had made, and for the afternoon was absolutely free. Every day or two I strolled to the village to hear some of the gossip which is incessantly going on there, circulating either from mouth to mouth, or from newspaper to newspaper, and which, taken in homœopathic doses, was really as refreshing in its way as the rustle of leaves and the peeping of frogs. As I walked in the woods to see the birds and squirrels, so I walked in the village to see the men and boys; instead of the wind among the pines I heard the carts rattle.

Walden Pond
(overleaf) Marsh, Lincoln

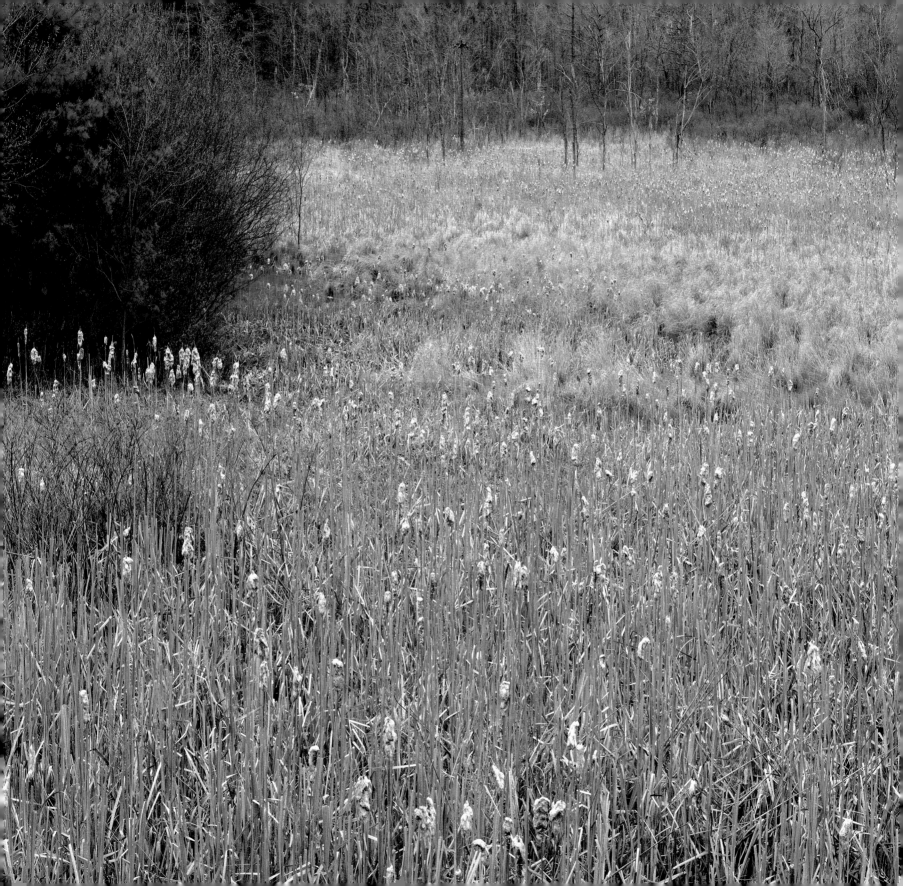

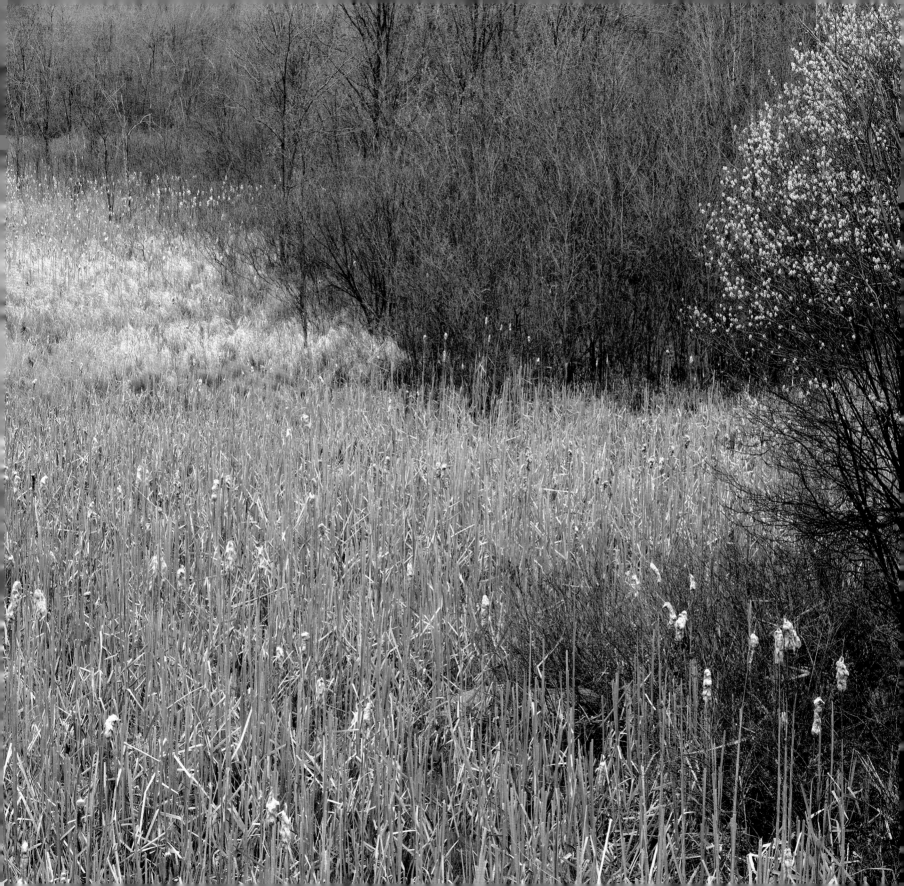

WE MIGHT TRY OUR LIVES by a thousand simple tests; as, for instance, that the same sun which ripens my beans illumines at once a system of earths like ours. If I had remembered this it would have prevented some mistakes. This was not the light in which I hoed them. The stars are the apexes of what wonderful triangles! What distant and different beings in the various mansions of the universe are contemplating the same one at the same moment! Nature and human life are as various as our several constitutions. Who shall say what prospect life offers to another? Could a greater miracle take place than for us to look through each other's eyes for an instant? We should live in all the ages of the world in an hour; ay, in all the worlds of the ages. History, Poetry, Mythology!—I know of no reading of another's experience so startling and informing as this would be.

Near Fairhaven Cliffs

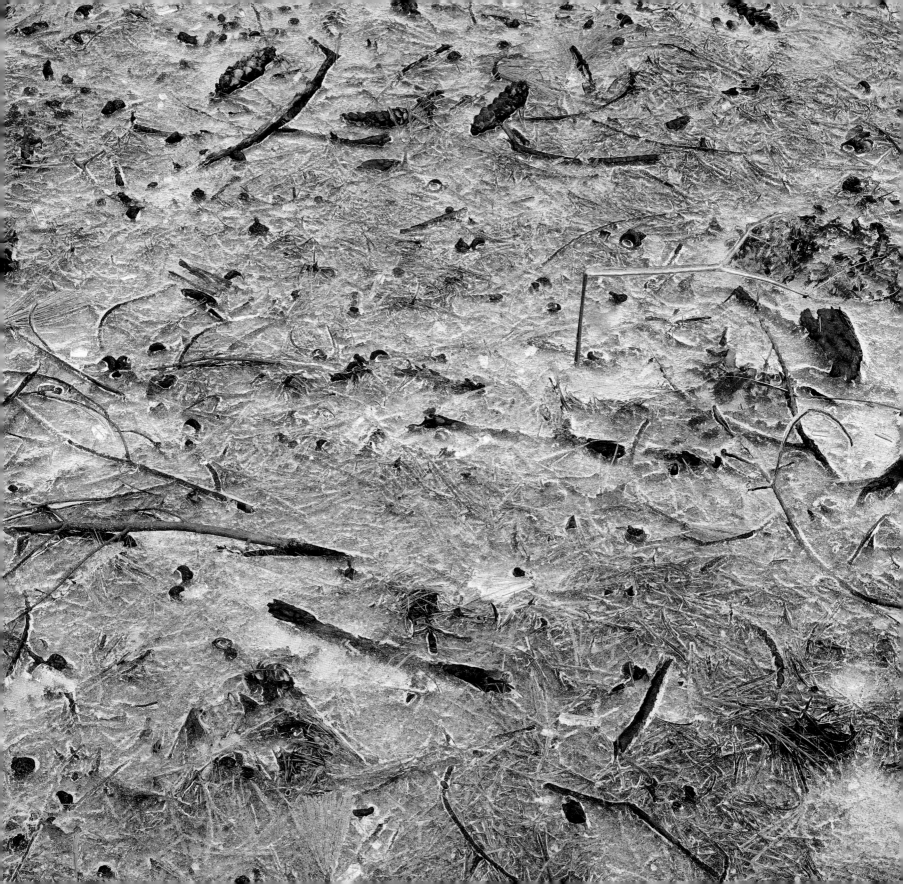

The Ponds

THE SCENERY OF WALDEN is on a humble scale, and, though very beautiful, does not approach to grandeur, nor can it much concern one who has not long frequented it or lived by its shore; yet this pond is so remarkable for its depth and purity as to merit a particular description. It is a clear and deep green well, half a mile long and a mile and three quarters in circumference, and contains about sixty-one and a half acres; a perennial spring in the midst of pine and oak woods, without any visible inlet or outlet except by the clouds and evaporation. The surrounding hills rise abruptly from the water to the height of forty to eighty feet, though on the south-east and east they attain to about one hundred and one hundred and fifty feet respectively, within a quarter and a third of a mile. They are exclusively woodland. All our Concord waters have two colors at least, one when viewed at a distance, and another, more proper, close at hand. The first depends more on the light, and follows the sky. In clear weather, in summer, they appear blue at a little distance, especially if agitated, and at a great distance all appear alike. In stormy weather they are sometimes of a dark slate color. The sea, however, is said to be blue one day and green another without any perceptible change in the atmosphere. I have seen our river, when, the landscape being covered with snow, both water and ice were almost as green as grass. Some consider blue "to be the color of pure water, whether liquid or solid." But, looking directly down into

our waters from a boat, they are seen to be of very different colors. Walden is blue at one time and green at another, even from the same point of view. Lying between the earth and the heavens, it partakes of the color of both. Viewed from a hill-top it reflects the color of the sky, but near at hand it is of a yellowish tint next the shore where you can see the sand, then a light green, which gradually deepens to a uniform dark green in the body of the pond. In some lights, viewed even from a hill-top, it is of a vivid green next the shore. Some have referred this to the reflection of the verdure; but it is equally green there against the railroad sand-bank, and in the spring, before the leaves are expanded, and it may be simply the result of the prevailing blue mixed with the yellow of the sand. Such is the color of its iris. This is that portion, also, where in the spring, the ice being warmed by the heat of the sun reflected from the bottom, and also transmitted through the earth, melts first and forms a narrow canal about the still frozen middle. Like the rest of our waters, when much agitated, in clear weather, so that the surface of the waves may reflect the sky at the right angle, or because there is more light mixed with it, it appears at a little distance of a darker blue than the sky itself; and at such a time, being on its surface, and looking with divided vision, so as to see the reflection, I have discerned a matchless and indescribable light blue, such as watered or changeable silks and sword blades suggest, more cerulean than the sky itself, alternating with the original dark green on the opposite sides of the waves, which last appeared but muddy in

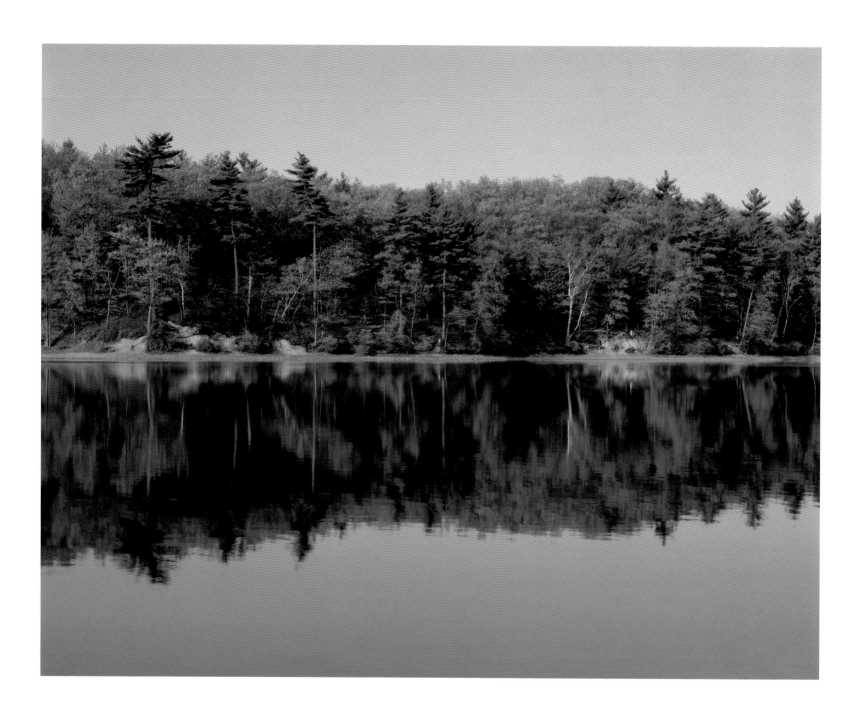

comparison. It is a vitreous greenish blue, as I remember it, like those patches of the winter sky seen through cloud vistas in the west before sundown. Yet a single glass of its water held up to the light is as colorless as an equal quantity of air. It is well known that a large plate of glass will have a green tint, owing, as the makers say, to its "body," but a small piece of the same will be colorless. How large a body of Walden water would be required to reflect a green tint I have never proved. . . .

The shore is composed of a belt of smooth rounded white stones like paving stones, excepting one or two short sand beaches, and is so steep that in many places a single leap will carry you into water over your head; and were it not for its remarkable transparency, that would be the last to be seen of its bottom till it rose on the opposite side. Some think it is bottomless. It is nowhere muddy, and a casual observer would say that there were no weeds at all in it; and of noticeable plants, except in the little meadows recently overflowed, which do not properly belong to it, a closer scrutiny does not detect a flag nor a bulrush, nor even a lily, yellow or white, but only a few small heart-leaves and potamogetons, and perhaps a water-target or two; all which however a bather might not perceive; and these plants are clean and bright like the element they grow in. The stones extend a rod or two into the water, and then the bottom is pure sand, except in the deepest parts, where there is usually a little sediment, probably from the decay of the leaves which have been wafted on to it so many successive falls, and a bright green weed is brought up on anchors even in midwinter.

Walden Pond, facing south

THE RISE AND FALL OF WALDEN at long intervals serves this use at least; the water standing at this great height for a year or more, though it makes it difficult to walk round it, kills the shrubs and trees which have sprung up about its edge since the last rise, pitch-pines, birches, alders, aspens, and others, and, falling again, leaves an unobstructed shore; for, unlike many ponds and all waters which are subject to a daily tide, its shore is cleanest when the water is lowest. On the side of the pond next my house, a row of pitch pines fifteen feet high has been killed and tipped over as if by a lever, and thus a stop put to their encroachments; and their size indicates how many years have elapsed since the last rise to this height. By this fluctuation the pond asserts its title to a shore, and thus the shore is shorn, and the trees cannot hold it by right of possession. These are the lips of the lake on which no beard grows. It licks its chaps from time to time. When the water is at its height, the alders, willows, and maples send forth a mass of fibrous red roots several feet long from all sides of their stems in the water, and to the height of three or four feet from the ground, in the effort to maintain themselves; and I have known the high-blueberry bushes about the shore, which commonly produce no fruit, bear an abundant crop under these circumstances.

Walden Pond, facing south

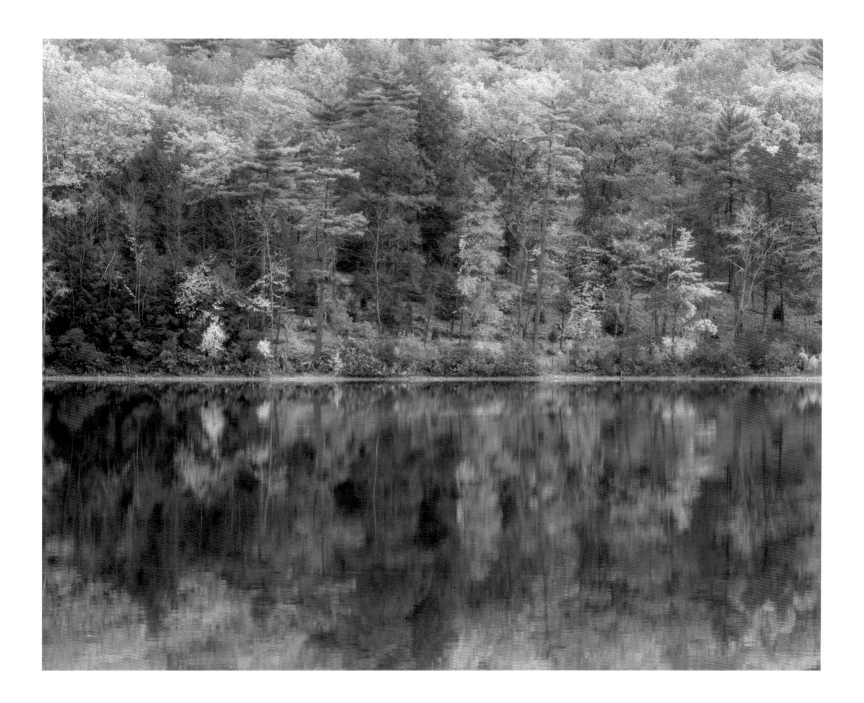

THE SHORE IS IRREGULAR ENOUGH not to be monotonous. I have in my mind's eye the western indented with deep bays, the bolder northern, and the beautifully scolloped southern shore, where successive capes overlap each other and suggest unexplored coves between. The forest has never so good a setting, nor is as distinctly beautiful, as when seen from the middle of a small lake amid hills which rise from the water's edge; for the water in which it is reflected not only makes the best foreground in such a case, but, with its winding shore, the most natural and agreeable boundary to it. There is no rawness nor imperfection in its edge there, as where the axe has cleared a part, or a cultivated field abuts on it. The trees have ample room to expand on the water side, and each sends forth its most vigorous branch in that direction. There Nature has woven a natural selvage, and the eye rises by just gradations from the low shrubs of the shore to the highest trees. There are few traces of man's hand to be seen. The water laves the shore as it did a thousand years ago.

Walden Pond, facing southwest
(overleaf) Wyman's Meadow

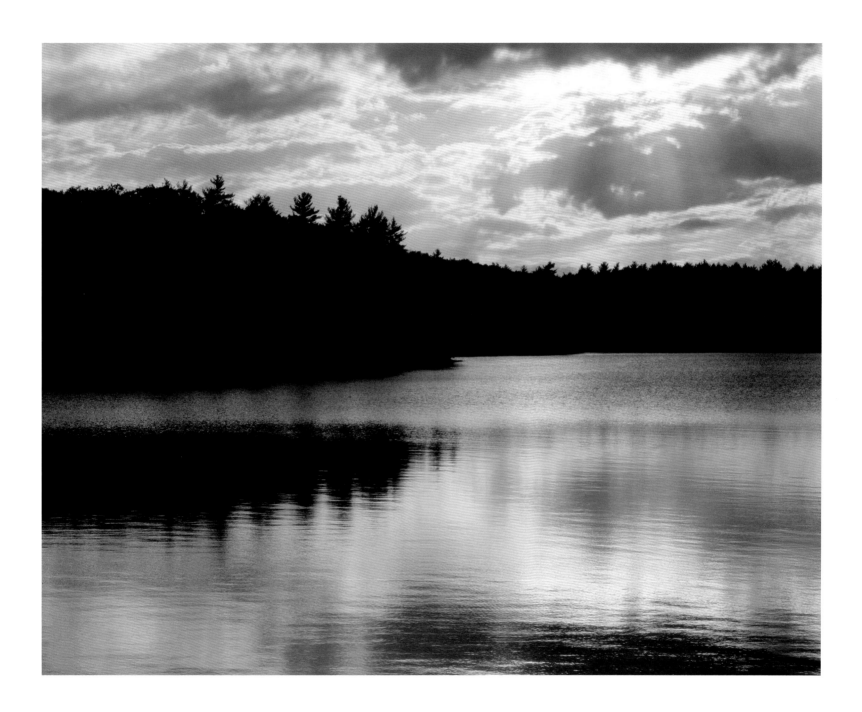

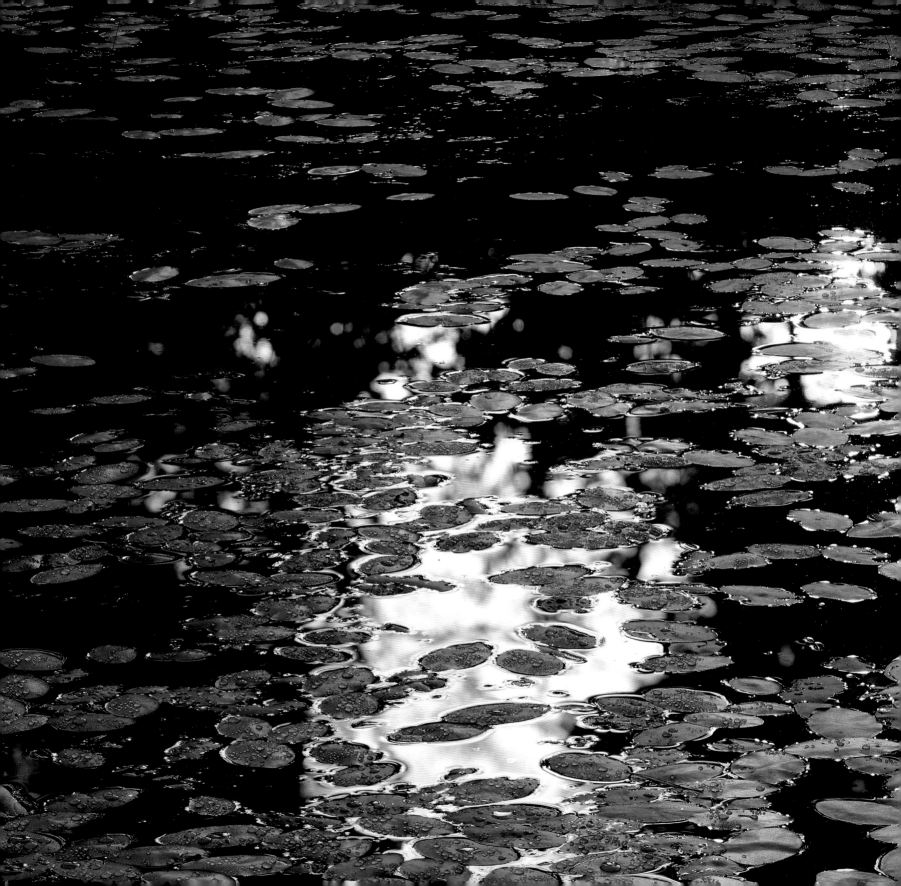

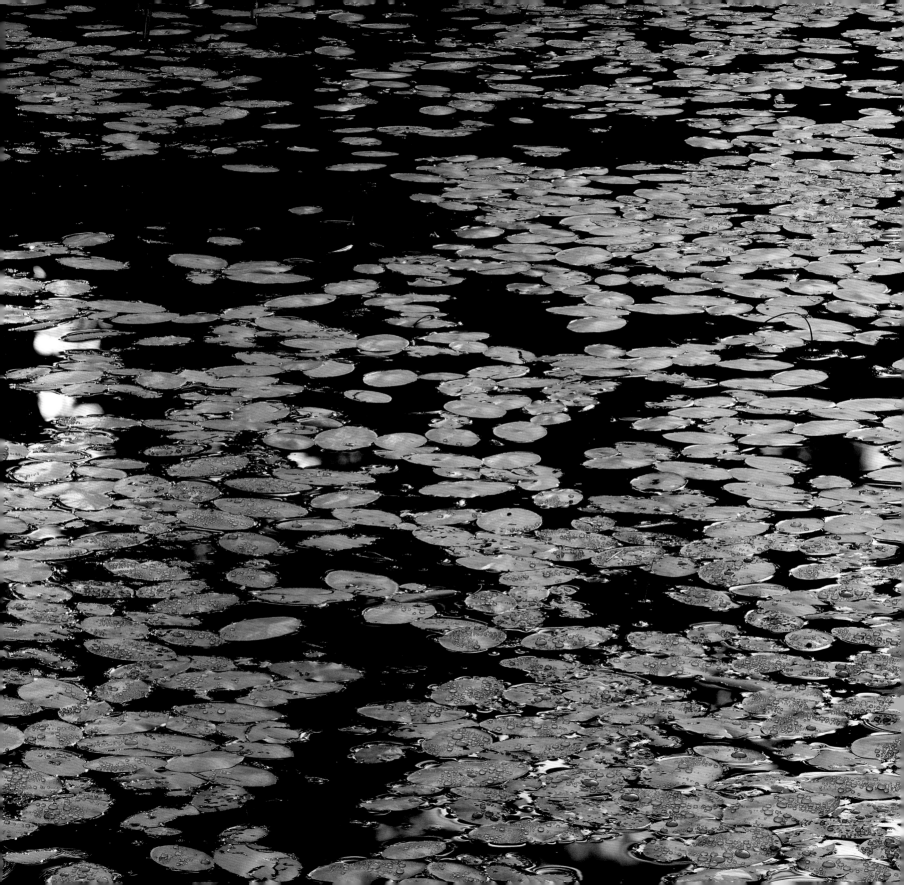

A LAKE IS THE LANDSCAPE's most beautiful and expressive feature. It is earth's eye; looking into which the beholder measures the depth of his own nature.

Wyman's Meadow

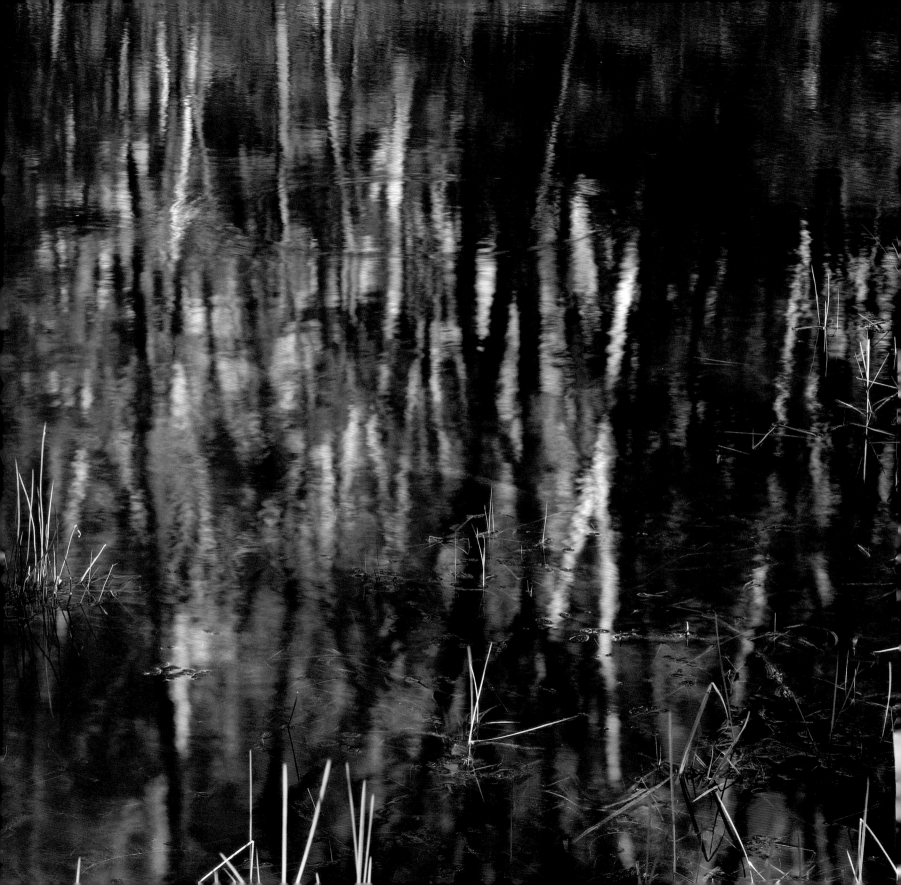

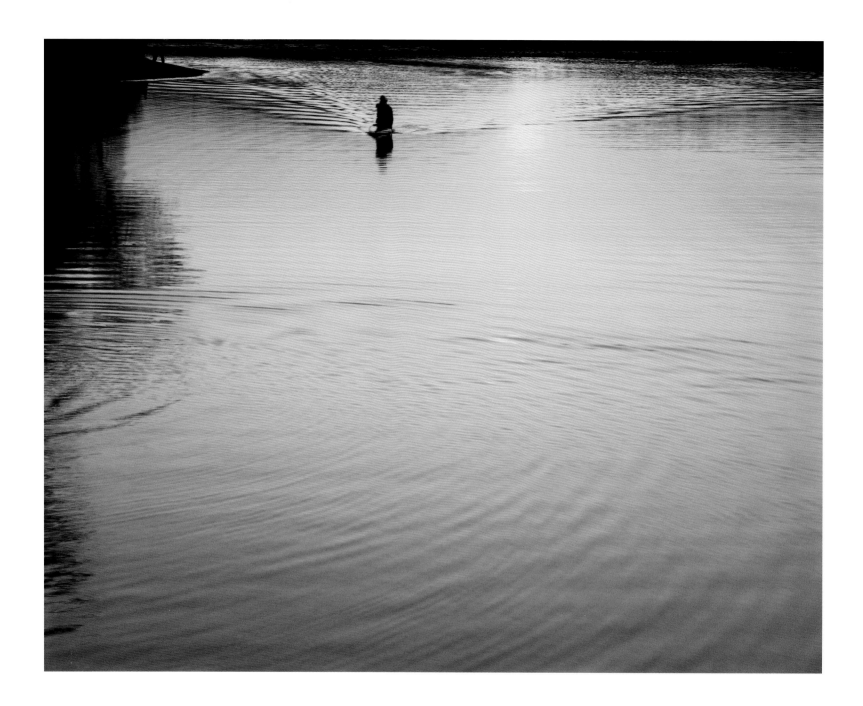

WHEN I FIRST PADDLED A BOAT ON WALDEN, it was completely surrounded by thick and lofty pine and oak woods, and in some of its coves grape vines had run over the trees next the water and formed bowers under which a boat could pass. The hills which form its shores are so steep, and the woods on them were then so high, that, as you looked down from the west end, it had the appearance of an amphitheatre for some kind of sylvan spectacle. I have spent many an hour, when I was younger, floating over its surface as the zephyr willed, having paddled my boat to the middle, and lying on my back across the seats, in a summer forenoon, dreaming awake, until I was aroused by the boat touching the sand, and I arose to see what shore my fates had impelled me to; days when idleness was the most attractive and productive industry. Many a forenoon have I stolen away, preferring to spend thus the most valued part of the day; for I was rich, if not in money, in sunny hours and summer days, and spent them lavishly; nor do I regret that I did not waste more of them in the workshop or the teacher's desk. But since I left those shores the woodchoppers have still further laid them waste, and now for many a year there will be no more rambling through the aisles of the wood, with occasional vistas through which you see the water. My Muse may be excused if she is silent henceforth. How can you expect the birds to sing when their groves are cut down?

Walden Pond

Baker Farm

INSTEAD OF CALLING ON SOME SCHOLAR, I paid many a visit to particular trees, of kinds which are rare in this neighborhood, standing far away in the middle of some pasture, or in the depths of a wood or swamp, or on a hill-top; such as the black-birch, of which we have some handsome specimens two feet in diameter; its cousin the yellow-birch, with its loose golden vest, perfumed like the first; the beech, which has so neat a bole and beautifully lichen-painted, perfect in all its details, of which, excepting scattered specimens, I know but one small grove of sizable trees left in the township, supposed by some to have been planted by the pigeons that were once baited with beech nuts near by; it is worth the while to see the silver grain sparkle when you split this wood; the bass; the hornbeam; the celtis occidentalis, or false elm, of which we have but one well-grown; some taller mast of a pine, a shingle tree, or a more perfect hemlock than usual, standing like a pagoda in the midst of the woods; and many others I could mention. These were the shrines I visited both summer and winter.

Eastern shore of Walden Pond

Higher Laws

AS I CAME HOME THROUGH THE WOODS with my string of fish, trailing my pole, it being now quite dark, I caught a glimpse of a woodchuck stealing across my path, and felt a strange thrill of savage delight, and was strongly tempted to seize and devour him raw; not that I was hungry then, except for that wildness which he represented. Once or twice, however, while I lived at the pond, I found myself ranging the woods, like a half-starved hound, with a strange abandonment, seeking some kind of venison which I might devour, and no morsel could have been too savage for me. The wildest scenes had become unaccountably familiar. I found in myself, and still find, an instinct toward a higher, or, as it is named, spiritual life, as do most men, and another toward a primitive rank and savage one, and I reverence them both. I love the wild not less than the good. The wildness and adventure that are in fishing still recommended it to me. I like sometimes to take rank hold on life and spend my day more as the animals do. Perhaps I have owed to this employment and to hunting, when quite young, my closest acquaintance with Nature. They early introduce us to and detain us in scenery with which otherwise, at that age, we should have little acquaintance. Fishermen, hunters, woodchoppers, and others, spending their lives in the fields and woods, in a peculiar sense a part of Nature themselves, are often in a more favorable mood for observing her, in the intervals of their pursuits, than philosophers or poets even, who approach her with expectation. She is not afraid to exhibit herself to them.

Bear Garden Hill

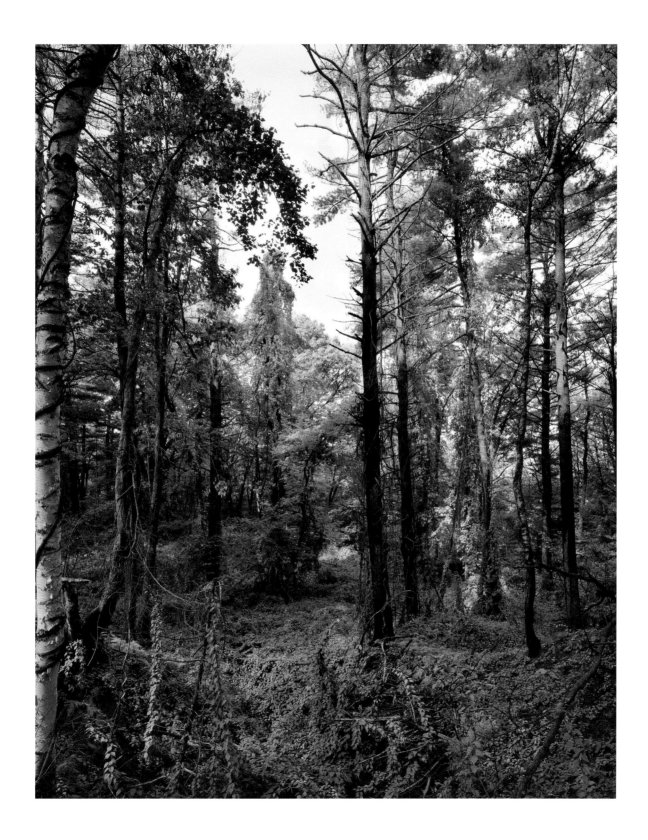

IF ONE LISTENS TO THE FAINTEST but constant suggestions of his genius, which are certainly true, he sees not to what extremes, or even insanity, it may lead him; and yet that way, as he grows more resolute and faithful, his road lies. The faintest assured objection which one healthy man feels will at length prevail over the arguments and customs of mankind. No man ever followed his genius till it misled him. Though the result were bodily weakness, yet perhaps no one can say that the consequences were to be regretted, for these were a life in conformity to higher principles. If the day and the night are such that you greet them with joy, and life emits a fragrance like flowers and sweet-scented herbs, is more elastic, more starry, more immortal,—that is your success. All nature is your congratulation, and you have cause momentarily to bless yourself. The greatest gains and values are farthest from being appreciated. We easily come to doubt if they exist. We soon forget them. They are the highest reality. Perhaps the facts most astounding and most real are never communicated by man to man. The true harvest of my daily life is somewhat as intangible and indescribable as the tints of morning or evening. It is a little star-dust caught, a segment of the rainbow which I have clutched.

Wyman's Meadow

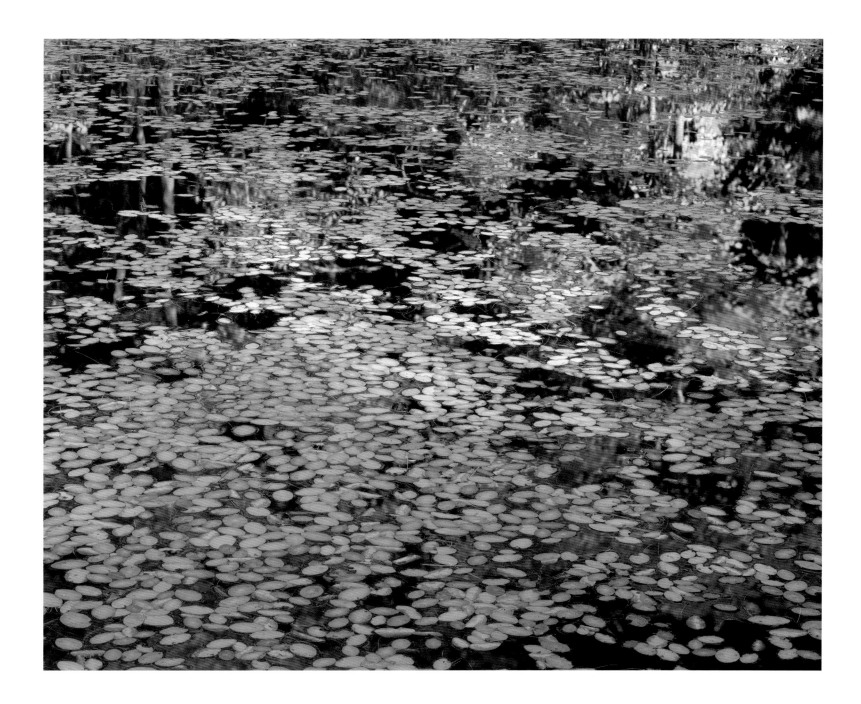

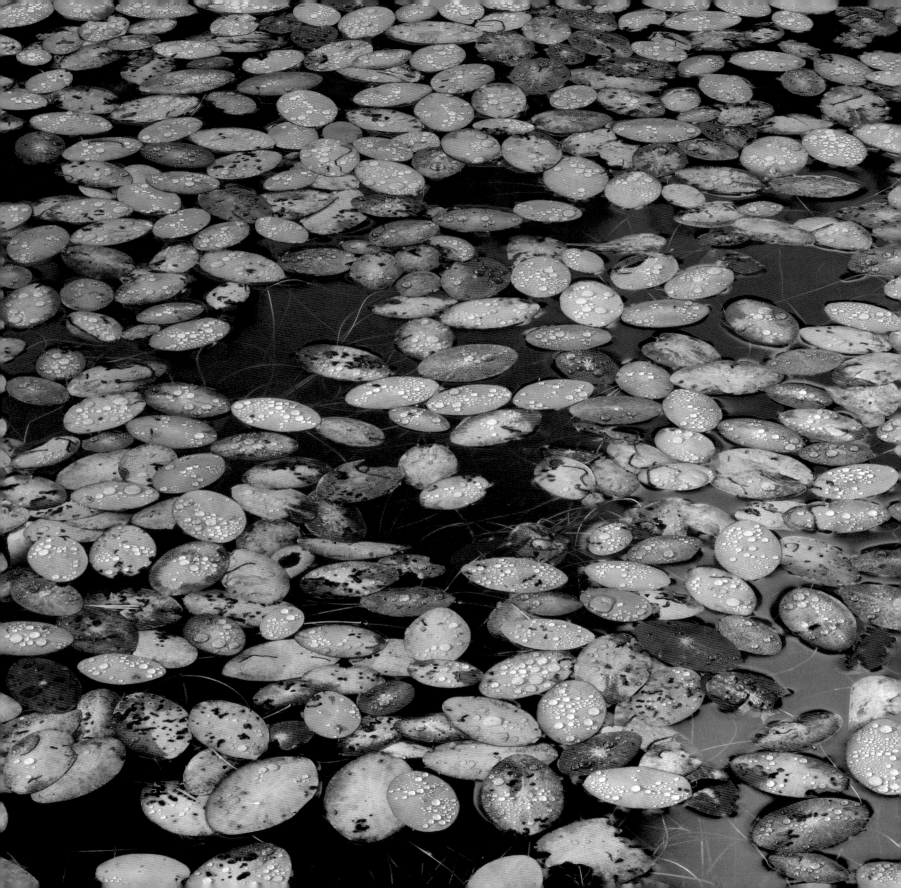

OUR WHOLE LIFE IS STARTLINGLY MORAL. There is never an instant's truce between virtue and vice. Goodness is the only investment that never fails. In the music of the harp which trembles round the world it is the insisting on this which thrills us. The harp is the travelling patterer for the Universe's Insurance Company, recommending its laws, and our little goodness is all the assessment that we pay. Though the youth at last grows indifferent, the laws of the universe are not indifferent, but are forever on the side of the most sensitive.

Wyman's Meadow

MAN FLOWS AT ONCE TO GOD when the channel of purity is open. By turns our purity inspires and our impurity casts us down. He is blessed who is assured that the animal is dying out in him day by day, and the divine being established.

Near Fairhaven Cliffs

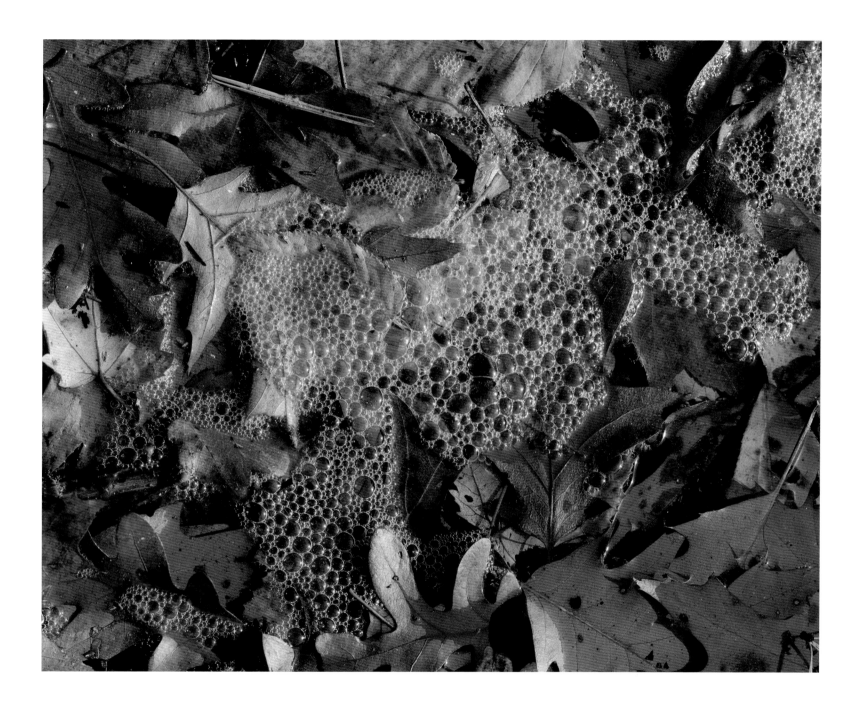

Brute Neighbors

IT IS REMARKABLE HOW MANY CREATURES live wild and free though secret in the woods, and still sustain themselves in the neighborhood of towns, suspected by hunters only. How retired the otter manages to live here! He grows to be four feet long, as big as a small boy, perhaps without any human being getting a glimpse of him. I formerly saw the raccoon in the woods behind where my house is built, and probably still heard their whinnering at night. Commonly I rested an hour or two in the shade at noon, after planting, and ate my lunch, and read a little by a spring which was the source of a swamp and of a brook, oozing from under Brister's Hill, half a mile from my field. The approach to this was through a succession of descending grassy hollows, full of young pitch-pines, into a larger wood about the swamp. There, in a very secluded and shaded spot, under a spreading white-pine, there was yet a clean firm sward to sit on. I had dug out the spring and made a well of clear gray water, where I could dip up a pailful without roiling it, and thither I went for this purpose almost every day in midsummer, when the pond was warmest. Thither too the wood-cock led her brood There too the turtle-doves sat over the spring, or fluttered from bough to bough of the soft white-pines over my head; or the red squirrel, coursing down the nearest bough, was particularly familiar and inquisitive. You only need sit still long enough in some attractive spot in the woods that all its inhabitants may exhibit themselves to you by turns.

Southern Shore, Walden Pond (detail)

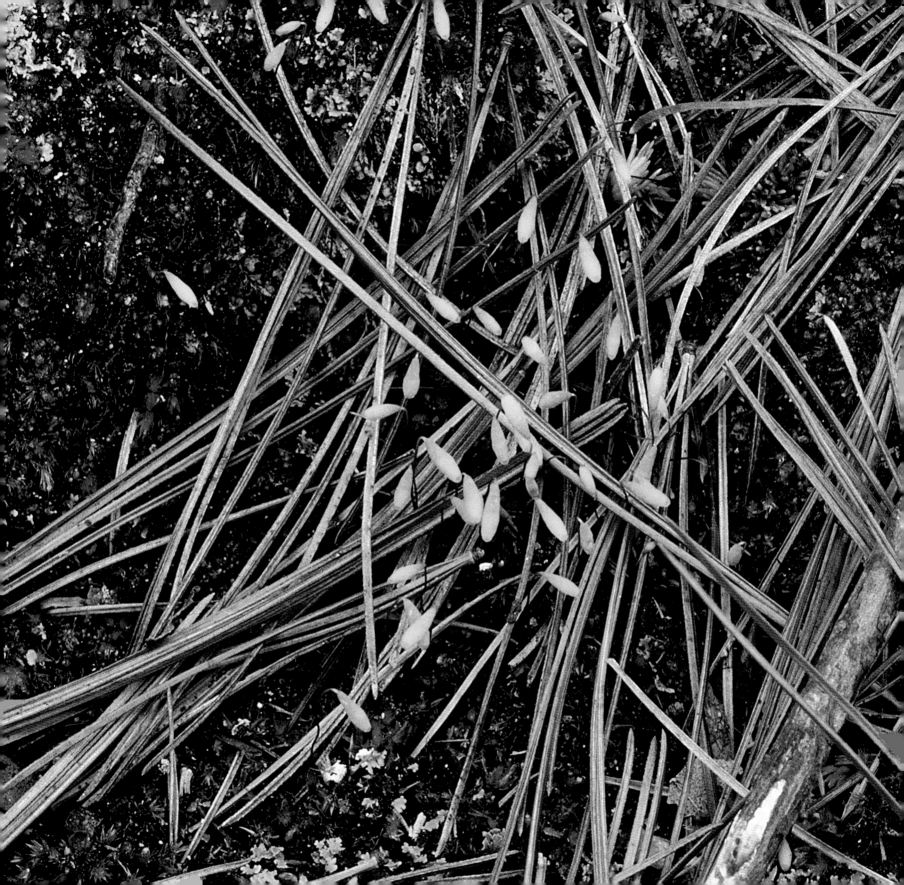

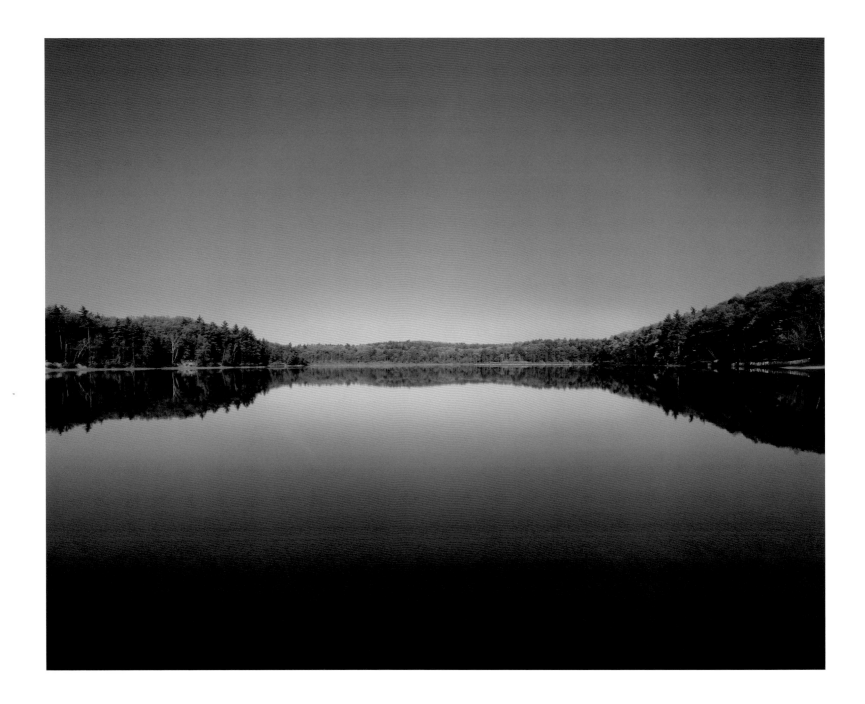

AS I WAS PADDLING ALONG the north shore one very calm October afternoon, for such days especially they settle on to the lakes, like the milkweed down, having looked in vain over the pond for a loon, suddenly one, sailing out from the shore toward the middle a few rods in front of me, set up his wild laugh and betrayed himself. I pursued with a paddle and he dived, but when he came up I was nearer than before. He dived again, but I miscalculated the direction he would take, and we were fifty rods apart when he came to the surface this time, for I had helped to widen the interval; and again he laughed long and loud, and with more reason than before. He manœuvred so cunningly that I could not get within half a dozen rods of him. Each time, when he came to the surface, turning his head this way and that, he coolly surveyed the water and the land, and apparently chose his course so that he might come up where there was the widest expanse of water and at the greatest distance from the boat. It was surprising how quickly he made up his mind and put this resolve into execution. He led me at once to the widest part of the pond, and could not be driven from it. While he was thinking one thing in his brain, I was endeavoring to divine his thought in mine.

Walden Pond, facing west

FOR HOURS, IN FALL DAYS, I watched the ducks cunningly tack and veer and hold the middle of the pond, far from the sportsman; tricks which they will have less need to practise in Louisiana bayous. When compelled to rise they would sometimes circle round and round and over the pond at a considerable height, from which they could easily see to other ponds and the river, like black motes in the sky; and, when I thought they had gone off thither long since, they would settle down by a slanting flight of a quarter of a mile on to a distant part which was left free; but what beside safety they got by sailing in the middle of Walden I do not know, unless they love its water for the same reason that I do.

Goose Pond

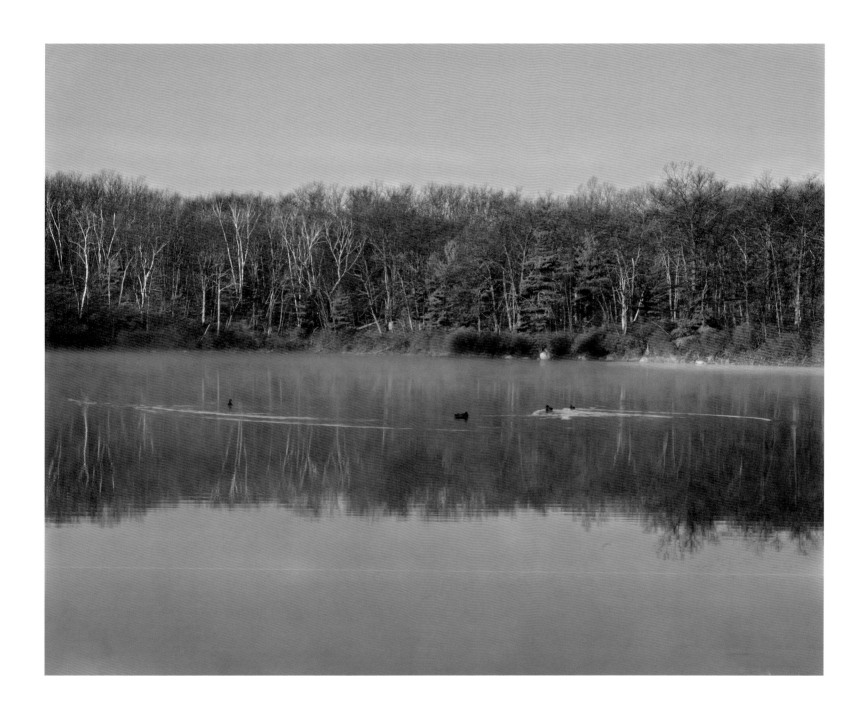

House-Warming

IN OCTOBER I WENT A-GRAPING to the river meadows, and loaded myself with clusters more precious for their beauty and fragrance than for food. There too I admired, though I did not gather, the cranberries, small waxen gems, pendants of the meadow grass, pearly and red.... The barberry's brilliant fruit was likewise food for my eyes merely; but I collected a small store of wild apples for coddling, which the proprietor and travellers had overlooked. When chestnuts were ripe I laid up half a bushel for winter. It was very exciting at that season to roam the then boundless chestnut woods of Lincoln,—they now sleep their long sleep under the railroad,—with a bag on my shoulder, and a stick to open burrs with in my hand, for I did not always wait for the frost, amid the rustling of leaves and the loud reproofs of the red-squirrels and the jays, whose half-consumed nuts I sometimes stole, for the burrs which they had selected were sure to contain sound ones. Occasionally I climbed and shook the trees. They grew also behind my house, and one large tree which almost overshadowed it, was, when in flower, a bouquet which scented the whole neighborhood, but the squirrels and the jays got most of its fruit; the last coming in flocks early in the morning and picking the nuts out of the burrs before they fell. I relinquished these trees to them and visited the more distant woods composed wholly of chestnut.

South of Walden Pond

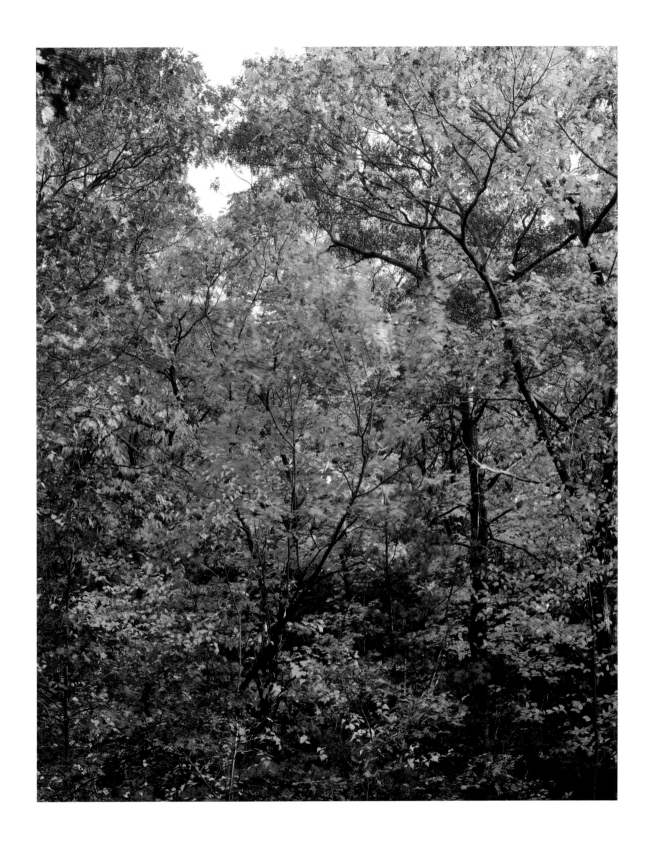

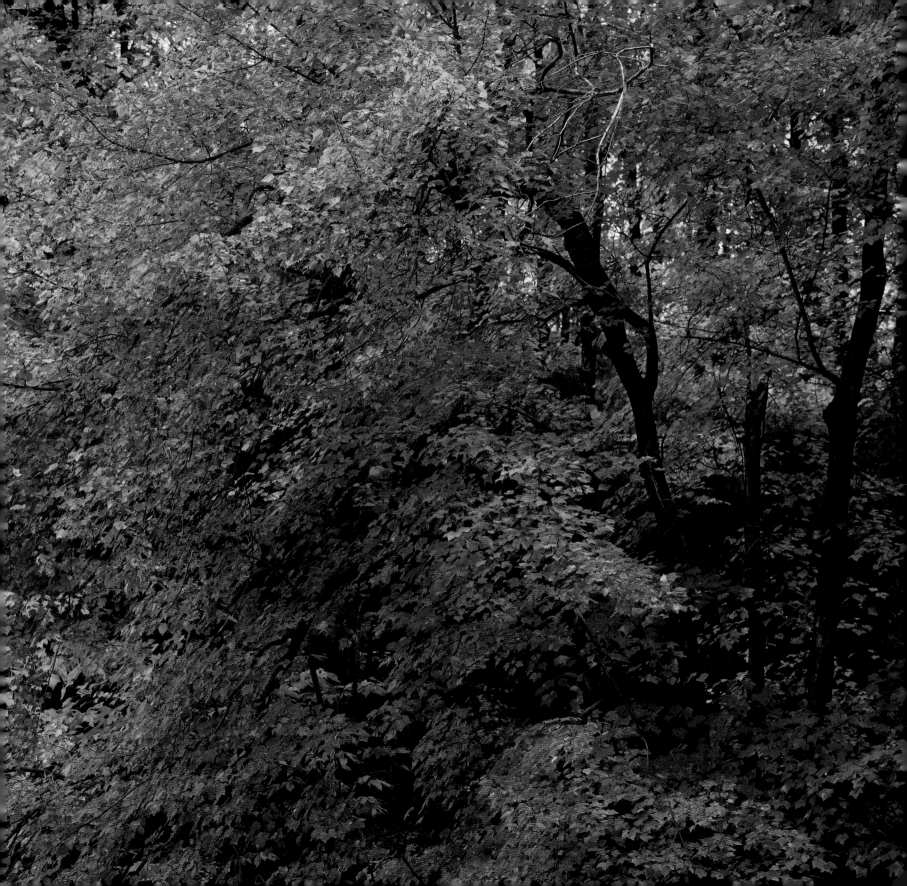

ALREADY, BY THE FIRST OF SEPTEMBER, I had seen two or three small maples turned scarlet across the pond, beneath where the white stems of three aspens diverged, at the point of a promontory, next the water. Ah, many a tale their color told! And gradually from week to week the character of each tree came out, and it admired itself reflected in the smooth mirror of the lake. Each morning the manager of this gallery substituted some new picture, distinguished by more brilliant or harmonious coloring, for the old upon the walls.

Near Wyman's Meadow

EVERY MAN LOOKS AT HIS WOOD-PILE with a kind of affection. I loved to have mine before my window, and the more chips the better to remind me of my pleasing work. I had an old axe which nobody claimed, with which by spells in winter days, on the sunny side of the house, I played about the stumps which I had got out of my bean-field. As my driver prophesied when I was ploughing, they warmed me twice, once while I was splitting them, and again when there were on the fire, so that no fuel could give out more heat. As for the axe, I was advised to get the village blacksmith to "jump" it; but I jumped him, and, putting a hickory helve from the woods into it, made it do. If it was dull, it was at least hung true.

North of Bear Garden Hill

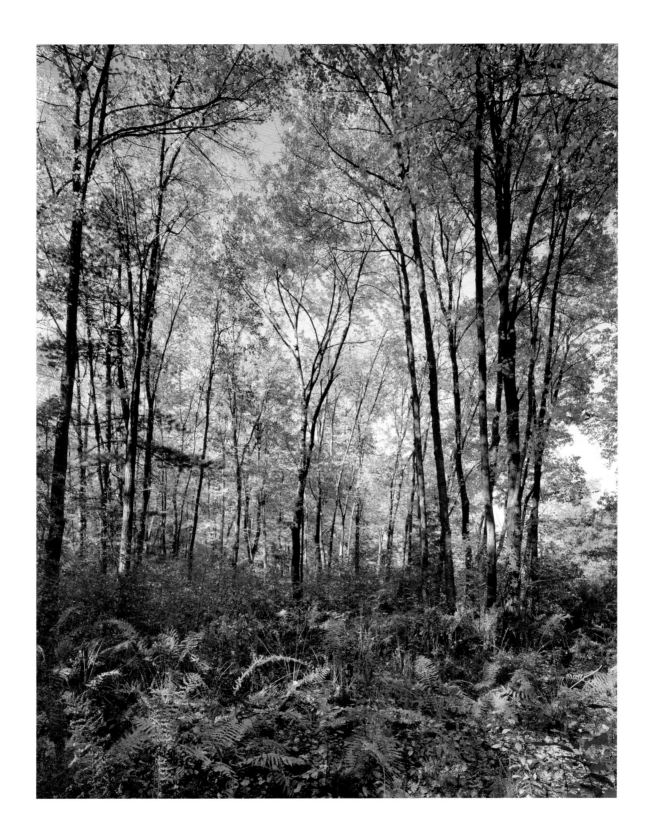

Former Inhabitants; and Winter Visitors

I WEATHERED SOME MERRY SNOW STORMS, and spent some cheerful winter evenings by my fire-side, while the snow whirled wildly without, and even the hooting of the owl was hushed. For many weeks I met no one in my walks but those who came occasionally to cut wood and sled it to the village. The elements, however, abetted me in making a path through the deepest snow in the woods, for when I had once gone through the wind blew the oak leaves into my tracks, where they lodged, and by absorbing the rays of the sun melted the snow, and so not only made a dry bed for my feet, but in the night their dark line was my guide.

Walden Pond, facing southwest

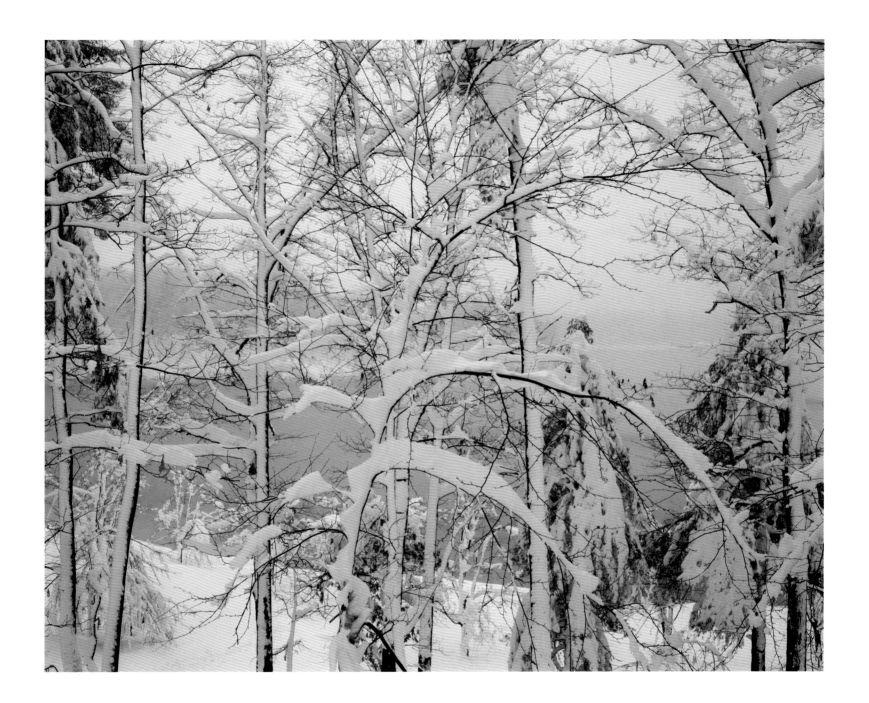

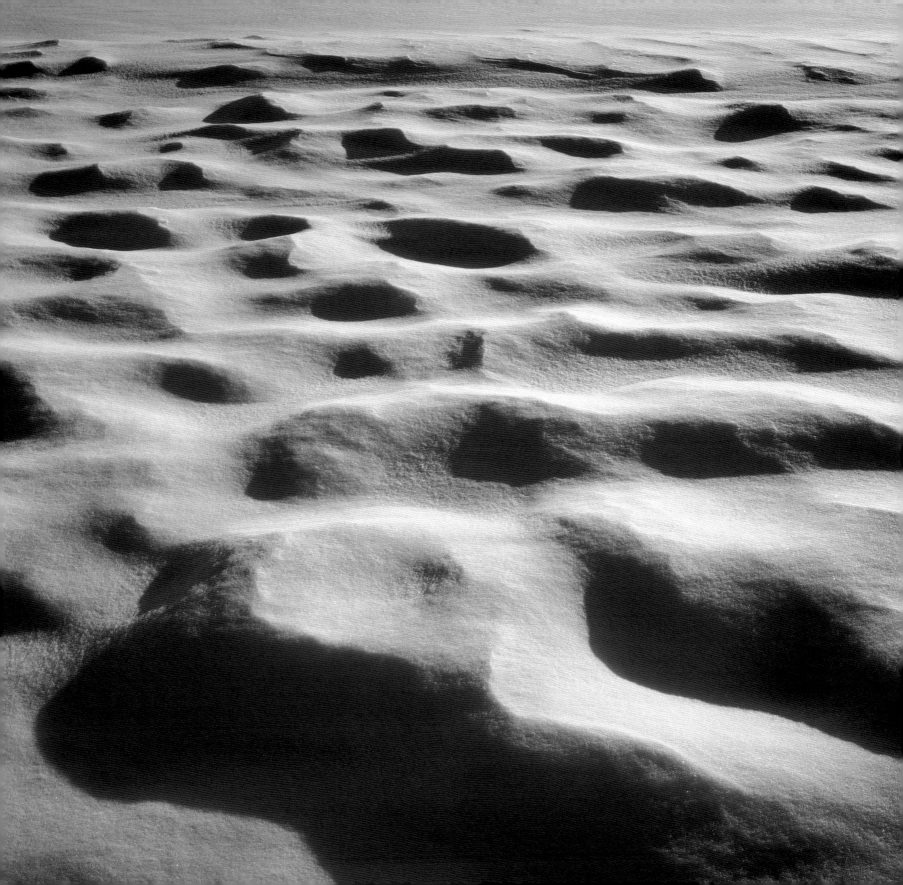

The Pond in Winter

STANDING ON THE SNOW-COVERED PLAIN, as if in a pasture amid the hills, I cut my way first through a foot of snow, and then a foot of ice, and open a window under my feet, where, kneeling to drink, I look down into the quiet parlor of the fishes, pervaded by a softened light as through a window of ground glass, with its bright sanded floor the same as in summer; there a perennial waveless serenity reigns as in the amber twilight sky, corresponding to the cool and even temperament of the inhabitants. Heaven is under our feet as well as over our heads.

Walden Pond

LIKE THE WATER, the Walden ice, seen near at hand, has a green tint, but at a distance is beautifully blue, and you can easily tell it from the white ice of the river, or the merely greenish ice of some ponds, a quarter of a mile off. Sometimes one of those great cakes slips from the ice-man's sled into the village street, and lies there for a week like a great emerald, an object of interest to all passers. I have noticed that a portion of Walden which in the state of water was green will often, when frozen, appear from the same point of view blue. So the hollows about this pond will, sometimes, in the winter, be filled with a greenish water somewhat like its own, but the next day will have frozen blue. Perhaps the blue color of water and ice is due to the light and air they contain, and the most transparent is the bluest. Ice is an interesting subject for contemplation.

Wyman's Meadow (detail)

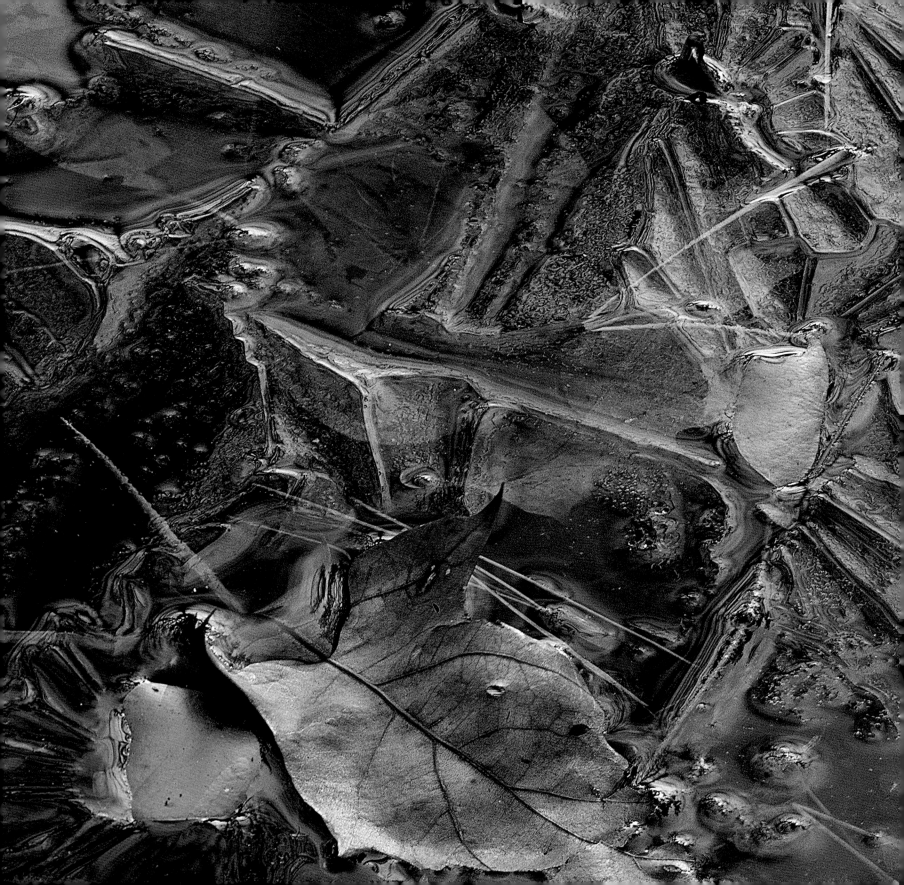

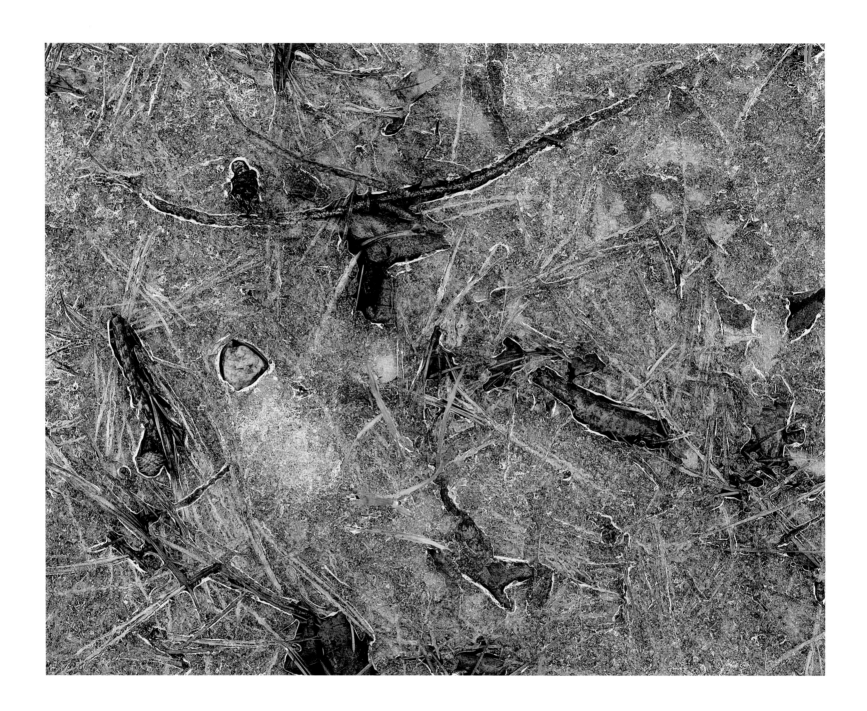

Spring

IN SPRING THE SUN NOT ONLY EXERTS an influence through the increased temperature of the air and earth, but its heat passes through ice a foot or more thick, and is reflected from the bottom in shallow water, and so also warms the water and melts the under side of the ice, at the same time that it is melting it more directly above, making it uneven, and causing the air bubbles which it contains to extend themselves upward and downward until it is completely honey-combed, and at last disappears suddenly in a single spring rain. Ice has its grain as well as wood, and when a cake begins to rot or "comb," that is, assume the appearance of a honey-comb, whatever may be its position, the air cells are at right angles with what was the water surface. Where there is a rock or a log rising near to the surface the ice over it is much thinner, and is frequently quite dissolved by this reflected heat. . . .

Near Fairhaven Cliffs

FEW PHENOMENA GAVE ME MORE DELIGHT than to observe the forms which thawing sand and clay assume in flowing down the sides of a deep cut on the railroad through which I passed on my way to the village, a phenomenon not very common on so large a scale, though the number of freshly exposed banks of the right material must have greatly multiplied since railroads were invented. The material was sand of every degree of fineness and of various rich colors, commonly mixed with a little clay. When the frost comes out in the spring, and even in a thawing day in the winter, the sand begins to flow down the slopes like lava, sometimes bursting out through the snow and overflowing it where no sand was seen before. Innumerable little streams overlap and interlace one with another, exhibiting a sort of hybrid product, which obeys half way the law of currents, and half way that of vegetation. As it flows it takes the forms of sappy leaves or vines, making heaps of pulpy sprays a foot or more in depth, and resembling, as you look down on them, the laciniated lobed and imbricated thalluses of some lichens; or you are reminded of coral, of leopards' paws or birds' feet. . . .

When the sun withdraws the sand ceases to flow, but in the morning the streams will start once more and branch and branch

again into a myriad of others. You here see perchance how blood vessels are formed. If you look closely you observe that first there pushes forward from the thawing mass a stream of softened sand with a drop-like point, like the ball of the finger, feeling its way slowly and blindly downward, until at last with more heat and moisture, as the sun gets higher, the most fluid portion, in its effort to obey the law to which the most inert also yields, separates from the latter and forms for itself a meandering channel or artery within that, in which is seen a little silvery stream glancing like lightning from one stage of pulpy leaves or branches to another, and ever and anon swallowed up in the sand. It is wonderful how rapidly yet perfectly the sand organizes itself as it flows, using the best material its mass affords to form the sharp edges of its channel. Such are the sources of rivers. In the silicious matter which the water deposits is perhaps the bony system, and in the still finer soil and organic matter the fleshy fibre or cellular tissue. What is man but a mass of thawing clay? The ball of the human finger is but a drop congealed. The fingers and toes flow to their extent from the thawing mass of the body. Who knows what the human body would expand and flow out to under a more genial heaven?

THIS IS THE FROST COMING OUT OF THE GROUND; this is Spring. It precedes the green and flowery spring, as mythology precedes regular poetry. I know of nothing more purgative of winter fumes and indigestions. It convinces me that Earth is still in her swaddling clothes, and stretches forth baby fingers on every side. Fresh curls spring from the baldest brow. There is nothing inorganic. These foliaceous heaps lie along the bank like the slag of a furnace, showing that Nature is "in full blast" within. The earth is not a mere fragment of dead history, stratum upon stratum like the leaves of a book, to be studied by geologists and antiquaries chiefly, but living poetry like the leaves of a tree, which precede flowers and fruit,—not a fossil earth, but a living earth; compared with whose great central life all animal and vegetable life is merely parasitic. Its throes will heave our exuviæ from their graves. You may melt your metals and cast them into the most beautiful moulds you can; they will never excite me like the forms which this molten earth flows out into. And not only it, but the institutions upon it, are plastic like clay in the hands of the potter.

Wyman's Meadow

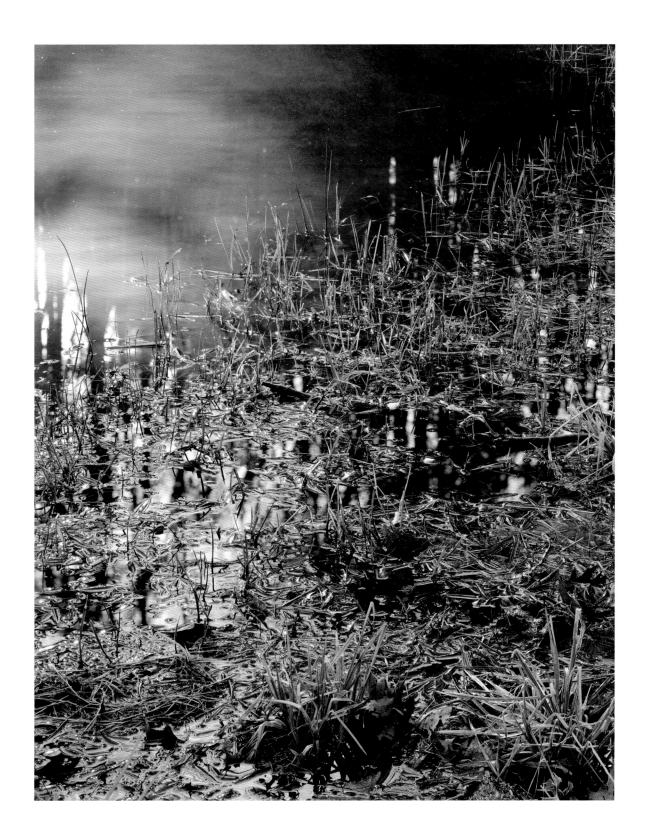

WHEN THE GROUND WAS PARTIALLY BARE OF SNOW, and a few warm days had dried its surface somewhat, it was pleasant to compare the first tender signs of the infant year just peeping forth with the stately beauty of the withered vegetation which had withstood the winter,—life-everlasting, golden-rods, pinweeds, and graceful wild grasses, more obvious and interesting frequently than in summer even, as if their beauty was not ripe till then; even cotton-grass, cat-tails, mulleins, johns-wort, hard-hack, meadow-sweet, and other strong stemmed plants, those unexhausted granaries which entertain the earliest birds,—decent weeds, at least, which widowed Nature wears. I am particularly attracted by the arching and sheaf-like top of the wool-grass; it brings back the summer to our winter memories, and is among the forms which art loves to copy, and which, in the vegetable kingdom, have the same relation to types already in the mind of man that astronomy has. It is an antique style older than Greek or Egyptian. Many of the phenomena of Winter are suggestive of an inexpressible tenderness and fragile delicacy. We are accustomed too hear this king described as a rude and boisterous tyrant; but with the gentleness of a lover he adorns the tresses of Summer.

Wyman's Meadow

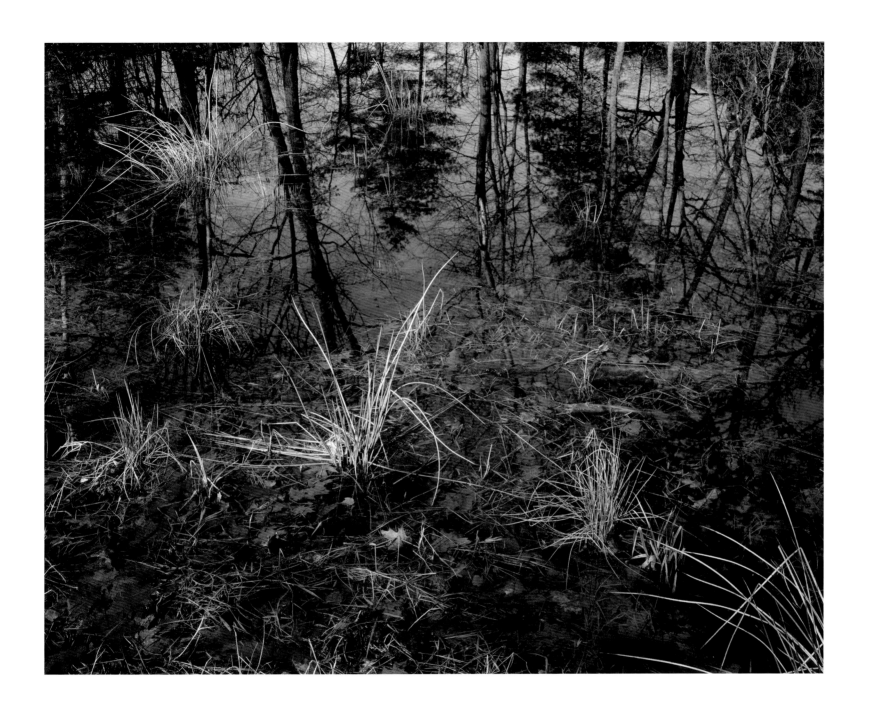

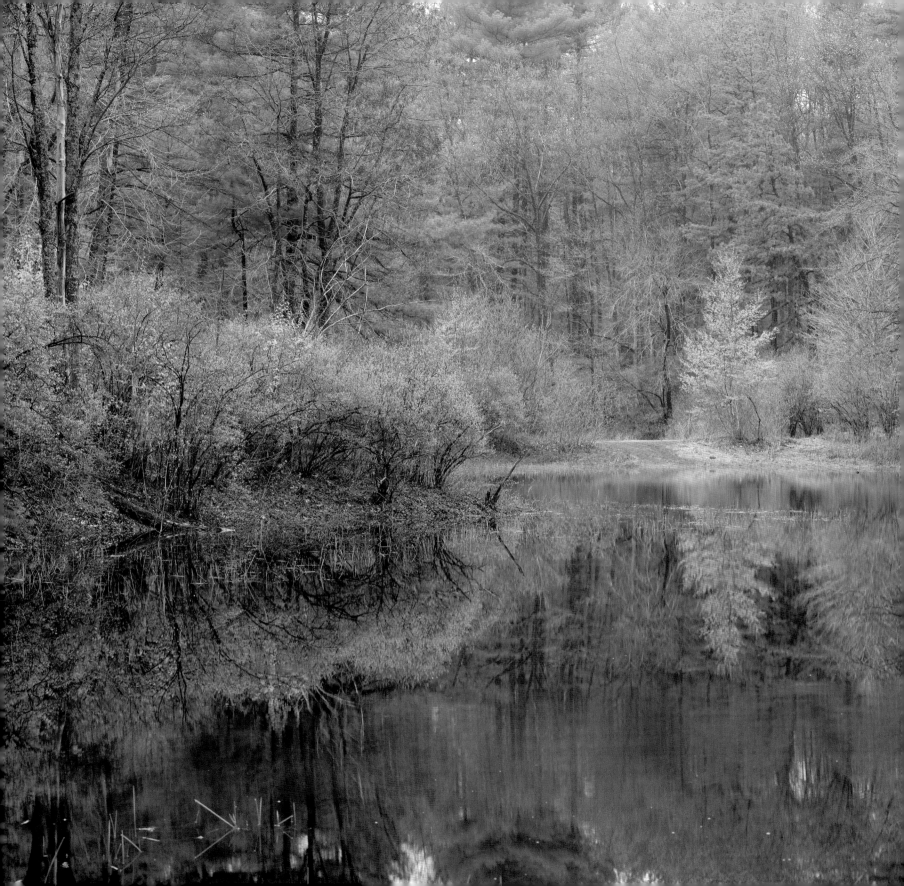

AS EVERY SEASON SEEMS BEST TO US IN ITS TURN, so the coming in of spring is like the creation of Cosmos out of Chaos and the realization of the Golden Age

A single gentle rain makes the grass many shades greener. So our prospects brighten on the influx of better thoughts. We should be blessed if we lived in the present always, and took advantage of every accident that befell us, like the grass which confesses the influence of the slightest dew that falls on it; and did not spend our time in atoning for the neglect of past opportunities, which we call doing our duty. We loiter in winter while it is already spring. In a pleasant spring morning all men's sins are forgiven. Such a day is a truce to vice. While such a sun holds out to burn, the vilest sinner may return. Through our own recovered innocence we discern the innocence of our neighbors. You may have known your neighbor yesterday for a thief, a drunkard, or a sensualist, and merely pitied or despised him, and despaired of the world; but the sun shines bright and warm this first spring morning, re-creating the world, and you meet him at some serene work, and see how his exhausted and debauched veins expand with still joy and bless the new day, feel the spring influence with the innocence of infancy, and all his faults are forgotten.

Wyman's Meadow

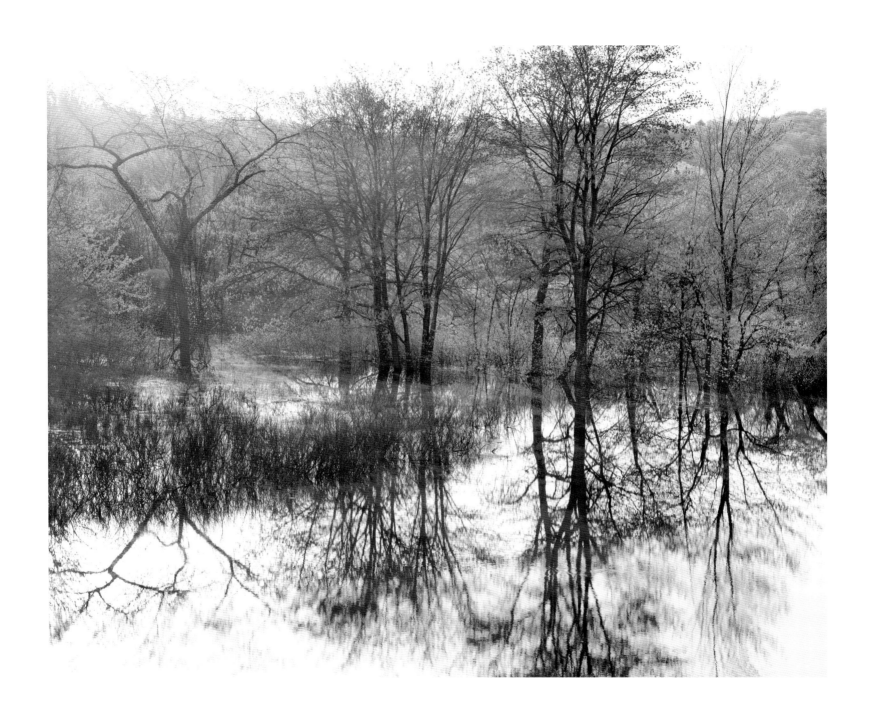

ON THE 29TH OF APRIL, as I was fishing from the bank of the river near the Nine-Acre-Corner bridge, standing on the quaking grass and willow roots, where the muskrats lurk, I heard a singular rattling sound, somewhat like that of the sticks which boys play with their fingers, when, looking up, I observed a very slight and graceful hawk, like a night-hawk, alternately soaring like a ripple and tumbling a rod or two over and over, showing the underside of its wings, which gleamed like a satin ribbon in the sun, or like the pearly inside of a shell. This sight reminded me of falconry and what nobleness and poetry are associated with that sport. The Merlin it seemed to me it might be called: but I care not for its name. It was the most ethereal flight I had ever witnessed. It did not simply flutter like a butterfly, nor soar like the larger hawks, but it sported with proud reliance in the fields of air; mounting again and again with its strange chuckle, it repeated its free and beautiful fall, turning over and over like a kite, and then recovering from its lofty tumbling, as if it had never set its foot on terra firma. It appeared to have no companion in the universe,—sporting there alone,—and to need none but the morning and the ether with which it played. It was not lonely, but made all the earth lonely beneath it. Where was the parent which hatched it, its kindred, and its father in the heavens? The tenant of the air, it seemed related to the earth but by an egg hatched some time in the crevice of a crag;—or was its native nest made in the angle of a cloud, woven of the rainbow's trimmings and the sunset sky, and lined with some soft midsummer haze caught up from earth? Its eyry now some cliffy cloud.

Sudbury River

OUR VILLAGE LIFE would stagnate if it were not for the unexplored forests and meadows which surround it. We need the tonic of wildness,—to wade sometimes in marshes where the bittern and the meadow-hen lurk, and hear the booming of the snipe; to smell the whispering sedge where only some wilder and more solitary fowl builds her nest, and the mink crawls with its belly close to the ground. At the same time that we are earnest to explore and learn all things, we require that all things be mysterious and unexplorable, that land and sea be infinitely wild, unsurveyed and unfathomed by us because unfathomable. We can never have enough of Nature. We must be refreshed by the sight of inexhaustible vigor, vast and Titanic features, the sea-coast with its wrecks, the wilderness with its living and its decaying trees, the thunder cloud, and the rain which lasts three weeks and produces freshets. We need to witness our own limits transgressed, and some life pasturing freely where we never wander.

Wyman's Meadow

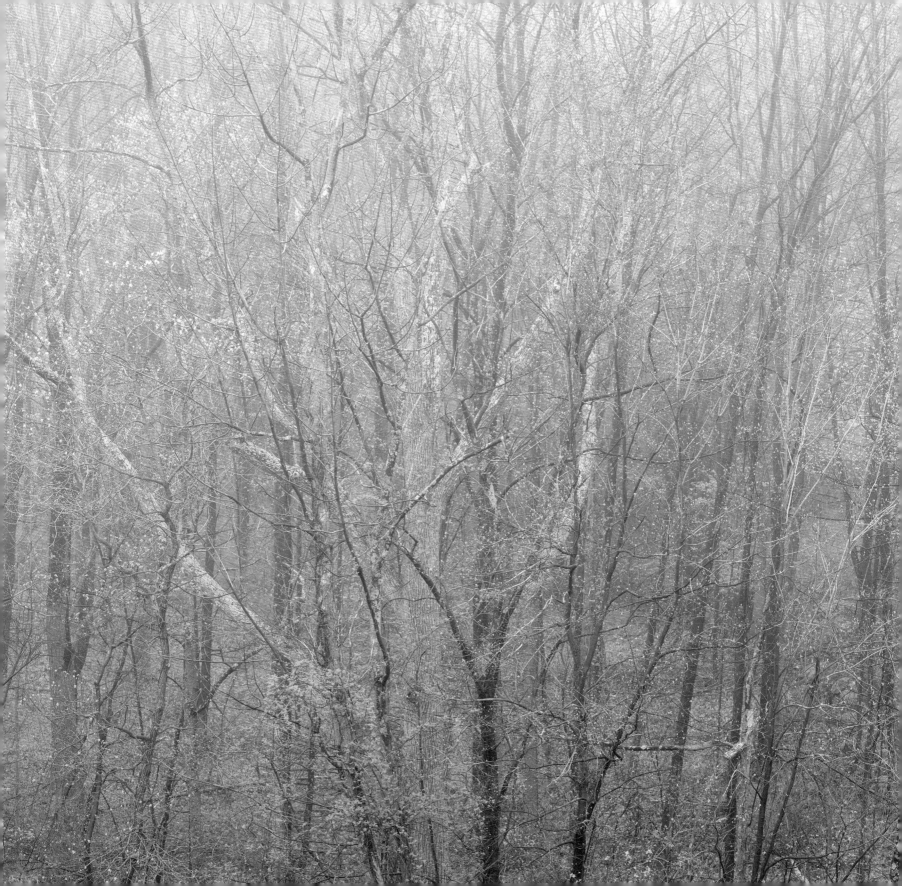

EARLY IN MAY, the oaks, hickories, maples, and other trees, just putting out amidst the pine woods around the pond, imparted a brightness like sunshine to the landscape, especially in cloudy days, as if the sun were breaking through mists and shining faintly on the hill-sides here and there. On the third or fourth of May I saw a loon in the pond, and during the first week of the month I heard the whippoorwill, the brown-thrasher, the veery, the wood-pewee, the chewink, and other birds. I had heard the wood-thrush long before. The phœbe had already come once more and looked in at my door and window, to see if my house was cavern-like enough for her, sustaining herself on humming wings with clinched talons, as if she held by the air, while she surveyed the premises.

Near Walden Pond

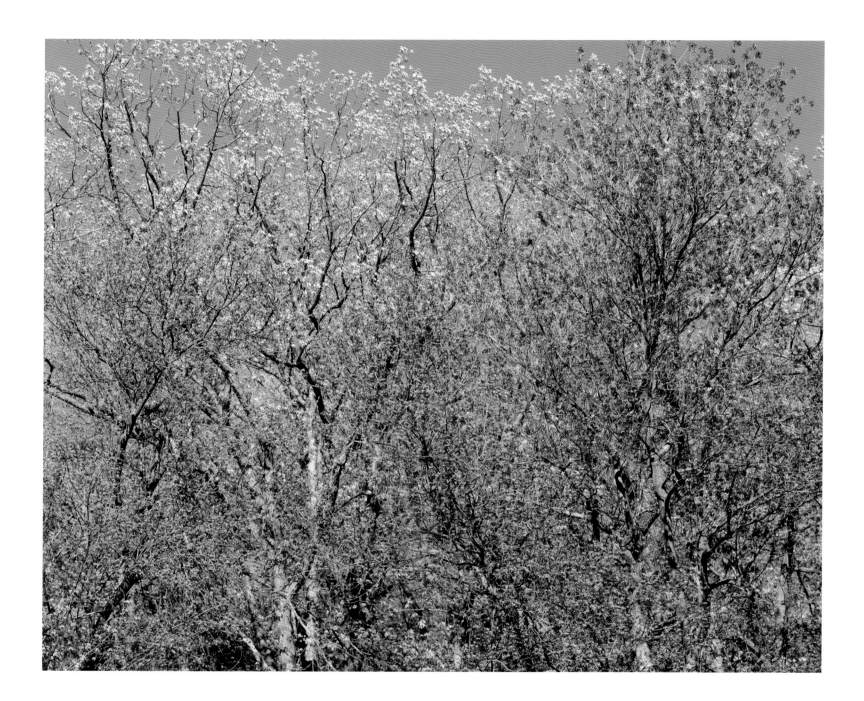

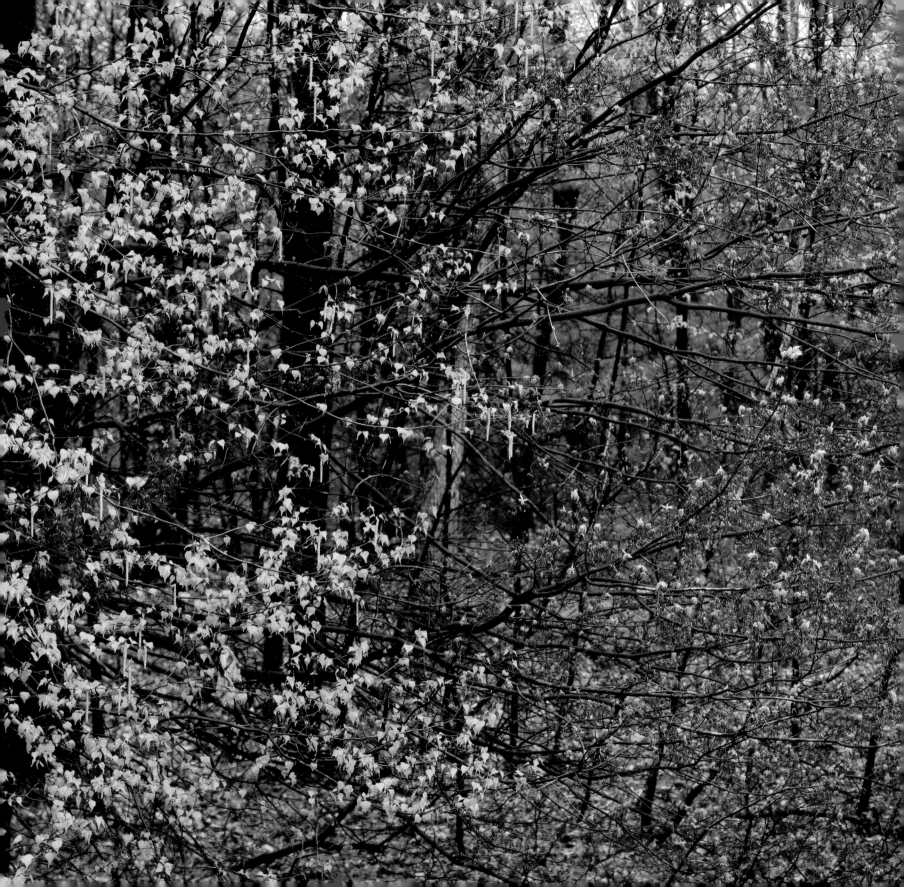

Conclusion

TO THE SICK the doctors wisely recommend a change of air and scenery. Thank Heaven, here is not all the world. The buck-eye does not grow in New England, and the mocking-bird is rarely heard here. The wild-goose is more of a cosmopolite than we; he breaks his fast in Canada, takes a luncheon in the Ohio, and plumes himself for the night in a southern bayou. Even the bison, to some extent, keeps pace with the seasons, cropping the pastures of the Colorado only till a greener and sweeter grass awaits him by the Yellowstone. Yet we think that if rail-fences are pulled down, and stone-walls piled up on our farms, bounds are henceforth set to our lives and our fates decided. If you are chosen town-clerk, forsooth, you cannot go to Tierra del Fuego this summer; but you may go to the land of infernal fire nevertheless. The universe is wider than our views of it.

Near Thoreau's Cove

I LEFT THE WOODS for as good a reason as I went there. Perhaps it seemed to me that I had several more lives to live, and could not spare any more time for that one. It is remarkable how easily and insensibly we fall into a particular route, and make a beaten track for ourselves. I had not lived there a week before my feet wore a path from my door to the pond-side; and though it is five or six years since I trod it, it is still quite distinct. It is true, I fear that others may have fallen into it, and so helped to keep it open. The surface of the earth is soft and impressible by the feet of men; and so with the paths which the mind travels. How worn and dusty, then, must be the highways of the world, how deep the ruts of tradition and conformity! I did not wish to take a cabin passage, but rather to go before the mast and on the deck of the world, for there I could best see the moonlight amid the mountains. I do not wish to go below now.

Path to Thoreau's Cabin Site

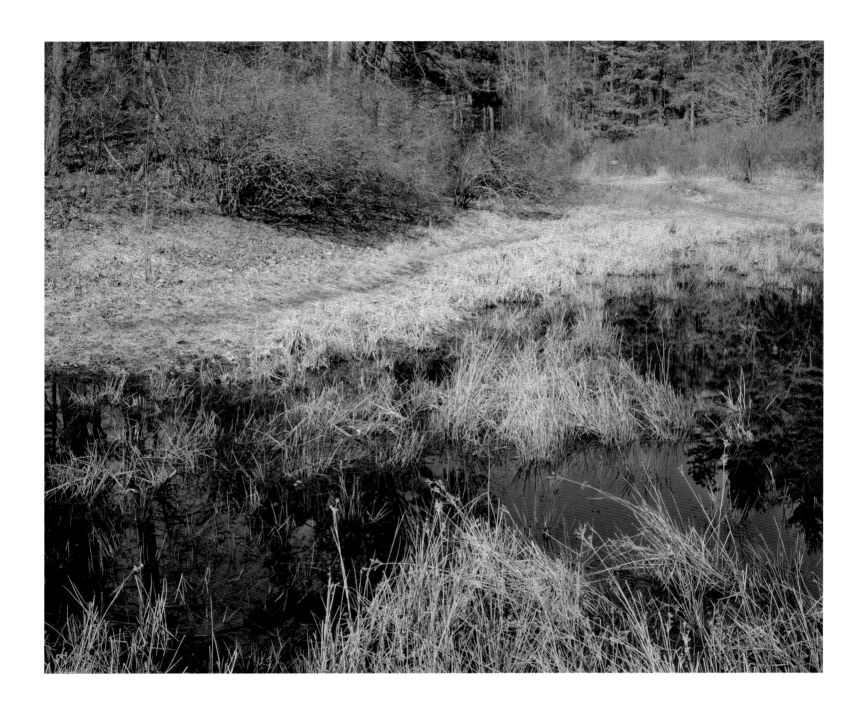

I LEARNED THIS, AT LEAST, by my experiment; that if one advances confidently in the direction of his dreams, and endeavors to live the life which he has imagined, he will meet with a success unexpected in common hours. He will put some things behind, will pass an invisible boundary; new, universal, and more liberal laws will begin to establish themselves around and within him; or the old laws be expanded, and interpreted in his favor in a more liberal sense, and he will live with the license of a higher order of beings. In proportion as he simplifies his life, the laws of the universe will appear less complex, and solitude will not be solitude, nor poverty poverty, nor weakness weakness. If you have built castles in the air, your work need not be lost; that is where they should be. Now put the foundations under them.

Wyman's Meadow

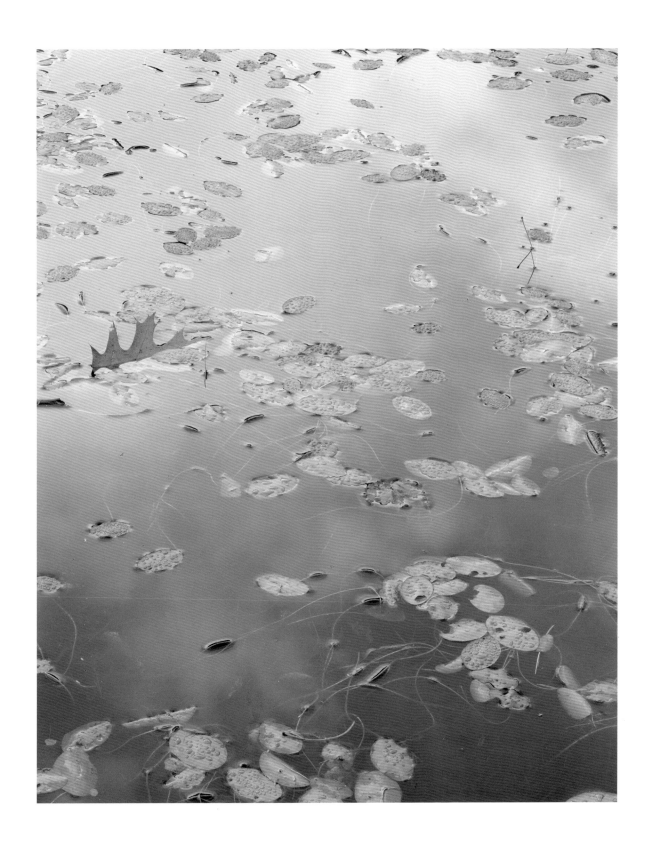

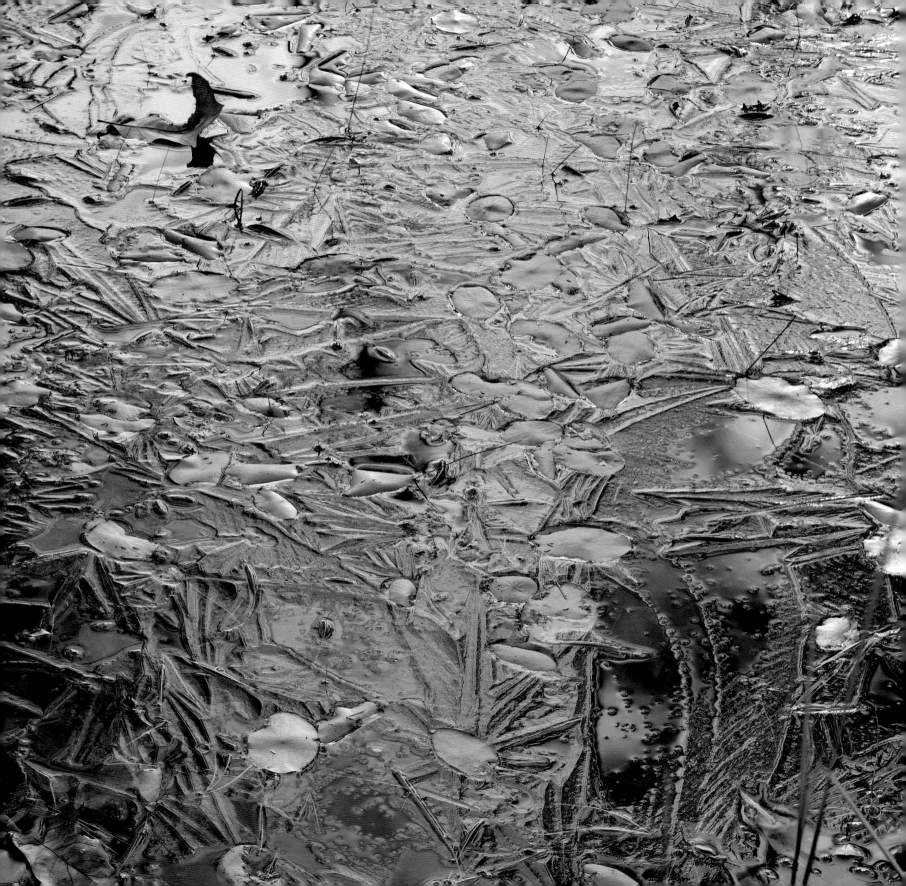

WHY SHOULD WE BE IN SUCH DESPERATE HASTE to succeed, and in such desperate enterprises? If a man does not keep pace with his companions, perhaps it is because he hears a different drummer. Let him step to the music which he hears, however measured or far away.

Wyman's Meadow

THE LIFE IN US IS LIKE THE WATER IN THE RIVER. It may rise this year higher than man has ever known it, and flood the parched uplands; even this may be the eventful year, which will drown out all our muskrats. It was not always dry land where we dwell. I see far inland the banks which the stream anciently washed, before science began to record its freshets. Every one has heard the story which has gone the rounds of New England, of a strong and beautiful bug which came out of the dry leaf of an old table of apple-tree wood, which had stood in a farmer's kitchen for sixty years, first in Connecticut, and afterward in Massachusetts,—from an egg deposited in the living tree many years earlier still, as appeared by counting the annual layers beyond it; which was heard gnawing out for several weeks, hatched perchance by the heat of an urn. Who does not feel his faith in a resurrection and immortality strengthened by hearing of this? Who knows what beautiful and winged life, whose egg has been buried for ages under many concentric layers of woodenness in the dead dry life of society, deposited at first in the alburnum of the green and living tree, which has been gradually converted into the semblance of its well-seasoned tomb,—heard perchance gnawing out now for years by the astonished family of man, as they sat round the festive board,—may unexpectedly come forth amidst society's most trivial and handselled furniture, to enjoy its perfect summer life at last!

. . .The light which puts out our eyes is darkness to us. Only that day dawns to which we are awake. There is more day to dawn. The sun is but a morning star.

New Pond

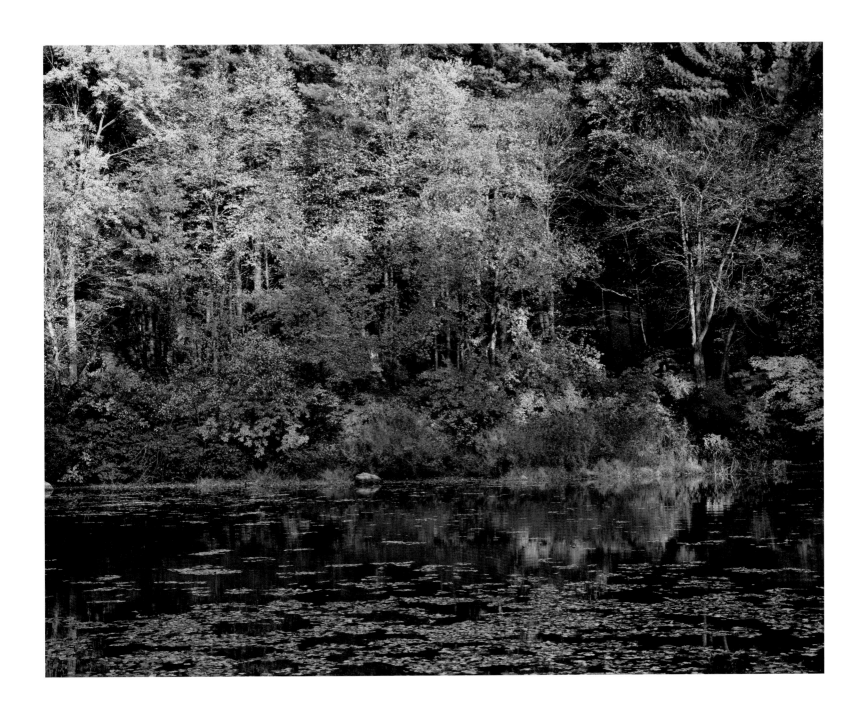

Plates

Appendix: About Thoreau and Walden Pond

HENRY DAVID THOREAU

Henry David Thoreau was born in Concord, Massachusetts, on July 12, 1817, and died there on May 6, 1862. His biographers have always found it difficult to categorize him through conventional pronouncements such as, "Thoreau was a" Over the course of his forty-four years, Thoreau was a teacher and tutor, a lecturer on the lyceum circuit, an author and literary naturalist, an abolitionist and political reformer, a philosopher, an environmentalist, a sojourner at Walden Pond, and an explorer of Concord's rivers, the Maine Woods, and Cape Cod. Defining Thoreau's life or character through reference to one or any combination of these activities does severe disservice to the range of his intellectual interests and imaginative expression, and certainly diminishes the profound impact his life and thought have exerted on American—indeed, on global—culture over the century-and-a-half since his death.

Thoreau's most straightforward explanation for his life and character comes at the conclusion of *Walden, or Life in the Woods* (1854) when he explains his reason for leaving the pond: believing he had more than one life to lead, he felt he could spare no more time on that one. His writings record the extraordinary accomplishment of an individual who, to paraphrase his own words, lived deep and sucked out all the marrow of life. *A Week on the Concord and Merrimack Rivers* (1849) re-creates an excursion he took with his brother John on those rivers in 1839; *Walden* reports the insights he gained while living at Walden Pond between July 4, 1845, and September 6, 1847; *The Maine Woods* (1864) recounts his three expeditions to the Maine wilderness between 1838 and 1857; and *Cape Cod* (1865) relates his four walking tours across that prized New England landscape between 1849 and 1857.

The fourteen volumes of his journal, which Thoreau began in 1837 at the suggestion of his friend and mentor Ralph Waldo Emerson, preserve the spontaneity, originality, and depth of his observations of and reflections on all that he saw and felt during the twenty-five-year span of his life these volumes record. A host of essays, many of them drawn from lectures but published only after his death, establish Thoreau as America's premier patriot and social critic, the earliest prophet of the advantages of a life lived wholly in concert with nature, and the most influential proponent for the preservation of the natural environment. For their blending of science with acute observation, "The Succession of Forest Trees" (1860) and the lyrical "Autumnal Tints" (1862) are two noteworthy examples of his natural history writings. In "Slavery in Massachusetts" (1854), "A Plea for Captain John Brown" (1859), and "Life without Principle" (1863), Thoreau develops some of his most passionate and sustained arguments against capitalism, the inhumanity of the institution of slavery, the perfidy of governments that suppress individual conscience, and the shame of those who, knowing better, fail to heed the dictates of individual conscience. *Walden* is unquestionably Thoreau's masterpiece, but had he written no more during his life, "Resistance to Civil Government" (1849) and "Walking" (1862) would have guaranteed his reputation. "Resistance to Civil Government"—better known to us as "Civil Disobedience"—has inspired momentous cultural transformations such as the nonviolent revolution led by Mahatma Gandhi in India, the civil rights movement led by the Reverend Martin Luther King, Jr., in the United States, and the global peace movement led by Daisaku Ikeda. "Walking," along with *Walden*, has inspired numerous champions of environmentalism, including John Muir, Rachel Carson, Edward Abbey, and Annie Dillard, and provided environmentalists and land preservationists everywhere with their first commandment: "In Wildness is the preservation of the world."

The Thoreau Society

Established in 1941, the Thoreau Society is the world's oldest and largest professional society devoted to the legacy of an American writer. The Thoreau Society adheres to the mission of honoring Henry David Thoreau by stimulating interest in and fostering education about his life, works, and philosophy, and his place in his world and ours; by coordinating research on his life and writings; by acting as a repository for material relevant to Thoreau; and by advocating for the preservation of Thoreau Country. The society collaborated with the Walden Woods Project to create the Thoreau Institute at Walden Woods, a research and educational center near Walden Pond. Under an agreement with the Massachusetts Department of Environmental Management (DEM), the society is the commonwealth's official friends organization for Walden Pond. Through programs that include public education and environmental conservation, the society's Friends of Walden Pond Committee promotes management activities jointly developed by DEM and the society that balance resource protection and enhancement with public use and enjoyment at the Walden Pond State Reservation.

For information about the Thoreau Society and its programs, and for membership information, write to the Society's administrative offices at 44 Baker Farm, Lincoln, MA 01773, U.S.A.; calla(781) 259-4750; or e-mail us at ThoreauSociety@walden.org.

The Walden Woods Project

A publicly-supported charity founded in 1990 by recording artist Don Henley, the Walden Woods Project has evolved into a highly regarded and successful conservation organization dedicated to protecting and restoring land in and around Walden Woods. This area, west of Boston, which inspired much of the philosophy and writings of American author and conservationist Henry David Thoreau, is widely acknowledged to be the cradle of the American environmental movement. The Walden Woods Project is continuing to protect and restore land within this historic ecosystem, and, in 1998, opened a research and educational center near Walden Pond. The Thoreau Institute at Walden Woods, a collaboration of the Walden Woods Project and the Thoreau Society, houses the society's incomparable collection of Thoreau-related material, maintains a comprehensive database of information relevant to Thoreau and to land protection and restoration, and offers a wide variety of environmental and humanities-based programs for teachers, students, and lifelong learners.

To learn more about the Walden Woods Project and how you can help support its mission, or about the Thoreau Institute at Walden Woods and its programs, write to the project's administrative offices at 44 Baker Farm, Lincoln, MA 01773, U.S.A.; call (781) 259-4700; or log on to www.walden.org.

RONALD A. BOSCO is Distinguished Service Professor of English and American Literature at the State University of New York at Albany, where he has taught since 1975. Since 1977, he has also been an editor of the Ralph Waldo Emerson papers at the Houghton Library of Harvard University. He is currently president of the Thoreau Society.

JOHN J. WAWRZONEK is senior partner of LightSong® Fine Art. He is trained in electrical engineering with three diplomas from the Massachusetts Institute of Technology and was employed by Bose Corporation from 1967 to 1990. Since 1974 he has photographed the New England landscape with a 4″ × 5″ view camera. His work has been exhibited widely and is in many private and public collections. This is his second book based on the writings of Henry David Thoreau, following *Walking*, published in 1993.

LightSong® Fine Art is the successor to a company John Wawrzonek established in 1977 to create a master-printing capability for publishing his own images. Prints are now made in the Luminage™ process, the modern successor to dye- and pigment-transfer processes used for many years by John and his colleague and master-printer, Michael Conrad.

The images in this volume are published by LightSong® Fine Art as superb Luminage™ prints in sizes as large as four feet by eight feet (1 × 2m). They will be shown beginning in 2002 in a special exhibit titled *The Illuminated™ Walden*. LightSong® Fine Art markets images of the natural landscape by many fine photographic artists. Clients include museums and art institutes and many Fortune 500 companies as well as private clients including Elton John, Tony Bennett, and others. John Wawrzonek's images have been widely exhibited throughout the United States.

For more information about LightSong® Fine Art and its publishing activities please visit our web site at www.LightSongFineArt.com or send an e-mail to light@LightSongFineArt.com. You may also call our administrative offices at (508) 561-7853 or write to LightSong® Fine Art, 73 Brimsmead Street, Marlboro, MA 01752, U.S.A. Fax: (508) 481-4651.